REGIONALISM: The California View

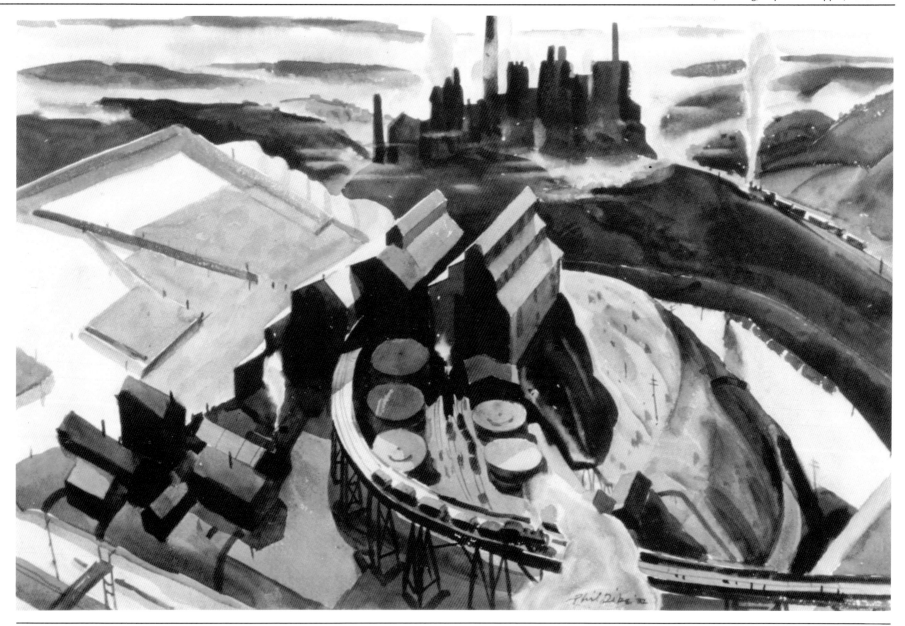

REGIONALISM
The California View

◆ *Watercolors 1929-1945*

◆ *Curators of the Exhibition*

Susan M. Anderson
Robert Henning, Jr.

Essay

Susan M. Anderson

◆ Santa Barbara Museum of Art
1988

REGIONALISM: The California View
Watercolors, 1929-1945

Santa Barbara Museum of Art
June 25-August 14, 1988

◆

Cover:
Upper left: Stan Backus, *Hoover Dam*
Upper right: Tom Craig, *Plaza Los Angeles*
Lower left: Rex Brandt, *Rain at Box Springs Camp*
 or *Evening at Box Springs Camp*
Lower right: James Patrick, *Untitled*

Published by the
Santa Barbara Museum of Art
1130 State Street
Santa Barbara, California 93101-2746

Distributed in association with
UNIVERSITY OF WASHINGTON PRESS,
Seattle and London.

Design/Production by Shelley Ruston and Margaret Dodd
Text set in Optima and Isbell by Friedrich Typography
Printed in an edition of 3000 by Haagen Printing

Photo Credits:
Rupp Aerial Photography, Inc., cover (upper left), p. 31;
Schenck and Schenck Photography, cover (upper right),
pp. 32, 42, 88; John Thompson, p. 39
Photographs on pp. 2, 12, 16, 19, 30, 33-35, 38, 40,
43-44, 46-47, 51-53, 55, 57-62, 64-65, 68, 73, 75,
77-79, 83, 85 and cover (lower left and right) courtesy of
the lenders. All other photographs (unless indicated in
captions) by Wayne McCall.

Library of Congress Cataloging-in-Publication Data

Regionalism: the California view, watercolors, 1929–1945.
 Bibliography: p.
 1. Watercolor painting, American—California—
Exhibitions. 2. Watercolor painting—20th century—
California—Exhibitions. 3. Regionalism in art—
Exhibitions. 4. California in art—Exhibitions.
I. Anderson, S. M. (Susan Mary) II. Henning, Robert.
III. Santa Barbara Museum of Art.
ND2365.R44 1988 759.194′074′019491 88-18214
ISBN 0-89951-072-8

Corporate Sponsor of the Exhibition

NORTHERN TRUST OF CALIFORNIA

*A wholly owned subsidiary of The Northern Trust Company,
Chicago, Illinois.*

*Publication of this catalogue has been made possible
by donations from Standish Backus, Jr., Gerald E. and
Bente Buck, E. Gene Crain, Phil and Betty Dike, Philip
H. Greene, Millard Sheets and donors who wish to
remain anonymous.*

CONTENTS

LENDERS TO THE EXHIBITION

Arlington Gallery, Santa Barbara, California
Standish Backus, Jr.
Jack Bennett
Lee Blair
Brigitta Beetz Bock
Robert and Nell Bonaparte
Joan Irving Brandt
Gary Breitweiser
The Buck Collection, Laguna Niguel, California
Chaffey Community Art Association, Ontario,
 California
Sam Colburn
The E. Gene Crain Collection, Laguna Beach,
 California
Mr. and Mrs. Robert W. Crisell
Raymond Cuevas
Phil and Betty Dike
Jack and Ursula Dimock
The Eclectic Gallery, Redlands, California
The Fieldstone Company, Newport Beach,
 California
Mr. and Mrs. Peter Fleurat
Mrs. Bernard Garbutt
Princess Dike Goodwin
Mrs. Hardie Gramatky
Mr. and Mrs. Philip H. Greene
Hood Museum of Art, Dartmouth College,
 Hanover, New Hampshire
Ed and Anne Hubert
Martin Isaacson
William A. Karges Fine Art, Carmel, California
Glen Knowles

Elizabeth Kosa
Jay T. Last
David Levine
Los Angeles County Fair Association, Pomona,
 California
Los Angeles County Museum of Art
Gordon and Debi McClelland
The Memorial Pathology Medical Group, Inc.
Ted Mills
Tobey C. Moss Gallery, Los Angeles, California
Nancy Dustin Wall Moure
The Oakland Museum
Peter and Gail Ochs
Edmund and Mercedes Penney
Pomona College, Claremont, California
James and Linda Ries
Mr. and Mrs. Michael Rupp
San Diego Museum of Art
Santa Barbara Museum of Art
Scripps College, Claremont, California
Jason Schoen
Terry Shannon-Payzant
Mr. and Mrs. Millard Sheets
David and Susan Stary-Sheets
George Stern, Fine Arts, Encino, California
Ralph and Lois Stone
Mike and Susan Verbal
John and Nancy Weare
Joseph Weisman
D. Wigmore Fine Art, Inc., New York, New York
Daphne B. Wood
Mrs. Jake Zeitlin

INTRODUCTION

The original concept for this exhibition was far less ambitious than its final form. Several years ago, at the urging of Professor Henri Dorra, I began to look at the work of some local artists whose careers were roughly parallel with the beginning years of the Santa Barbara Museum of Art—among them Stan Backus and Joseph Knowles, both members of the local art community—with the idea of assembling a small group show. This led to the discovery of work by other artists of their generation, work that was not well known but clearly represented an important aspect of American art. As word spread of our interest in artists working fifty years ago, several key people knowledgeable about California art offered their help and suggestions. Gary Breitweiser made me aware of the work done by Gordon McClelland, whose book (*The California Style,* Gordon T. McClelland and Jay T. Last, 1985) appeared at this point in our planning and proved an invaluable resource. A long luncheon meeting with Gary and Gordon convinced me that we had to broaden our exhibition concept to include work by numerous artists. We decided to focus on one aspect of their careers—the watercolors they produced mainly during the 1930s in a style that we have called California Regionalism.

In view of the fact that these artists do not, with a few minor exceptions, appear in standard books and articles on American Regionalism and many do not even receive recognition in texts on art of the 1930s and 1940s, we were aware of the pioneering nature of this endeavor. We were encouraged, however, by the obvious quality of the work that we discovered for this exhibition as well as the evidence we found to indicate that some of these artists had enjoyed national recognition and critical acclaim at one time.

In this first attempt at isolating and identifying a style, we have kept our definitions loose and our parameters fairly broad. At the same time, in order to limit ourselves to a manageable scope, we have elected to restrict the exhibition to watercolors produced in California between 1929 and 1945. The catalogue essay addresses in detail our reasoning for these decisions.

For the guest curator, I chose a young but well-qualified scholar with the intention of bringing a new and unprejudiced point of view to the subject because, while the artists selected have never appeared together under the rubric of "Regionalists," many of them have been written about or were known mainly for work other than that represented here. Primarily watercolorists, many developed other styles and subjects for which they are perhaps better known, after the period under examination here. I thought it important to consider this early aspect of their careers with a detached and objective eye. Susan M. Anderson has previously organized an exhibition of Regionalist prints (*From Native Soil: A Selection of American Regionalist Prints,* Montgomery Gallery, Pomona College, 1987); her enthusiastic and very thorough efforts on our project are clearly demonstrated in our exhibition and in this catalogue.

Many of the preliminary steps of locating and researching the early work of these artists had been taken by Gordon McClelland long before our project began; he must be credited with pursuing, identifying, studying, photographing, collecting and publishing much of what you see assembled here. He declined more official recognition for his efforts, but I would like to thank him for his outstanding generosity and his indispensable help at every stage of this project. Through his efforts many of these artists have been rediscovered and given the recognition they deserve. Other experts such as Janice Lovoos, the artists themselves, their friends and relations, helped us as well through their encouragement and the sharing of information at numerous meetings and discussions.

In the belief that this exhibition warranted a publication beyond the scope of our usual catalogue budget, I solicited help to expand the size of the edition and to increase the number of color illustrations. As a result, we received prompt and generous support from Millard Sheets, Standish Backus, Jr., Philip H. Greene, E. Gene Crain, Gerald E. and Bente Buck and Phil and Betty Dike. We are indebted to them and to the many artists, dealers and collectors who assisted in making this

catalogue a useful illustrated reference work in an area of great interest to our Museum.

Perhaps the initial and primary credit for this project should go to Donald Bear who, as first director of the Santa Barbara Museum of Art, stated: "Inasmuch as this new institution will function as a living art center in the community as well as a true museum, nothing could be more fitting than making its initial presentation to the public the art of our own country . . . Today the United States has the greatest number of young and gifted artists in the world . . . It is the duty of the American museum to help create an audience, not only for the artist of national prominence, but for those of local importance too." (*Painting Today and Yesterday in the United States,* Santa Barbara Museum of Art, 1941). Thanks to this dedication to "contemporary" American art and artists, the Museum in its first decade hosted regular exhibitions of the California Water Color Society and also presented exhibitions by a number of the artists represented here. It is appropriate that we return to these "roots" in order to recognize those artists who were a part of our early years by presenting this major survey and publication of their work.

This exhibition focuses on work rooted in the artists' California environment—expressed through diverse individual styles but capturing the characteristic quality of a place, an era and a relationship of people to their regional environment. These watercolors capture the flavor of everyday activities and the unmistakable atmosphere that prevailed in California during an important period in American history between the Depression and the Second World War. Some of the artists may differ as to whether they actively searched for the unique qualities of California life and locale or simply *imbibed* the spirit of the time, which led them to look at their immediate surroundings as a source of subjects worthy of painting. They also may not all agree on whether they set out to glorify, eulogize, criticize or merely record with detachment the world in which they lived. Therefore, there may be no single definition to the meaning of Regionalism that fits all the images represented here. What is demonstrated, however, is the fact that California's Regionalists deserve to be ranked with those artists whose names are synonymous with Regionalism. Our hope is that other exhibitions and publications will add to our discoveries and to this first effort, which we have tried to make as complete and as representative as possible.

The exhibition has been underwritten by Northern Trust of California; we greatly appreciate their interest in this important period in the history of California art. Their generosity made it possible to undertake the thorough research and travel necessary to assemble a comprehensive survey of work and to hire an outside scholar to assist in this project.

I am personally indebted to those many intermediaries who helped us trace elusive works and to all those who answered our countless questions. In addition, among those who assisted both Susan Anderson and me, we want to single out Wayne McCall, photographer; Shelley Ruston, Assistant Director for Publications and Programs, and Margaret Dodd, who worked together on the design and production of the catalogue; and editors Deanne Violich, Joan Crowder and Mrs. Earnest C. Watson. Finally, I would like to thank Curatorial Secretary Frances Warr and the Museum support staff, who looked after the myriad details of exhibition preparation, design and installation.

Robert Henning, Jr.
Chief Curator

ACKNOWLEDGMENTS

An exhibition like this one is created through the combined efforts of a great number of people. I am grateful for the enthusiastic response of all those who have been involved. Certainly I want to thank all the lenders to the exhibition for their graciousness in allowing me to visit their collections and for sharing their knowledge with me, especially Gordon McClelland, Susan and David Stary-Sheets, Mr. and Mrs. Philip H. Greene and John and Nancy Weare. Others particularly helpful were Jim and Peggy Lafferty, Gary Breitweiser, Jason Schoen, Jack and Ursula Dimock, Mike and Susan Verbal, Anne and Edgar Hubert. I would also like to thank Bruce Davis, Curator of Prints and Drawings, Los Angeles County Museum of Art; Arthur Monroe, Registrar, and Kate Chambers, Curatorial Aide, The Oakland Museum; Carmen Lacey, Curatorial Secretary, San Diego Museum of Art; Steve Comba, Registrar, The Galleries of the Claremont Colleges; Barbara J. MacAdam, Curator for American Art, and Rebecca Buck, Registrar, Hood Museum of Art, Dartmouth College; Robert George, Vice President, Chaffey Community Art Association; and Katherine Baumgartner, Gallery Assistant, D. Wigmore Fine Art, Inc.

I wish to express my warm appreciation to the many people who gave their knowledge freely during the course of organizing this exhibition, or who otherwise helped my research, including Janet Dominik; Nancy Moure; Terry St. John, Associate Curator of Painting, The Oakland Museum; Betty Hoag McGlynn; Mrs. Jake Zeitlin; Al Stendahl; Kent Seavey; Gael Donovan, Curator, Carmel Art Association; Stella Paul and Paul Karlstrom, Archives of American Art, Smithsonian Institution; Bruce and Jean Ariss; Dorothy Beeche; Ellwood Graham; Bob Perine; Tobey C. Moss; Ann Petersen, Registrar, Monterey Peninsula Museum of Art; Mary MacNaughton; Tim Mason; Craig G. St. Clair, Historian, *Los Angeles Times*; Teena Stern, Research Historian and Archivist, El Pueblo de Los Angeles State Historic Park; Bolton Colburn, Registrar, Laguna Beach Art Museum; Ellen Schwartz; and Sebastian Matthews.

My deepest appreciation goes to the contributing artists and their families who showed me unusual hospitality and patiently answered my many questions and to those individuals who made generous donations to the project, without which an exhibition of this scale would have been impossible.

Susan M. Anderson
Guest Curator

REGIONALISM: The California View

In the 1930s, a period of great social and economic change, American artists sought to free themselves from European influences in an effort to create a truly American art. Contemporary American art critics since the late 1920s had been advocating an American art that did not rely on European models for its inspiration. They called for an authentic native art, portraying subject matter in a realistic manner that could be readily understood by Americans in all parts of the country.

During the Great Depression following the stock market crash of late 1929, a wave of national consciousness swept the country, exerting a strong influence on writers, artists and other observers of the social scene. They sensed the need for new art forms that would capture the diverse environmental and social characteristics in various parts of the country. This regionalist focus found visual expression in an artistic movement strongly committed to the American experience.

Throughout the country a significant number of artists turned to painting the American scene. Artists like Grant Wood, John Steuart Curry and Thomas Hart Benton portrayed positive images of rural culture and its traditional values, concerns now commonly associated with the Regionalist movement. Other artists, oriented toward Social Realism like the painter Ben Shahn, forcefully documented the economic and social upheavals of the times. Edward Hopper and Charles Burchfield so vividly portrayed the universally relevant images of despair and isolation that their work, while firmly based in the American scene, transcends it. Generally speaking, most of the painters who turned toward American subject matter in the 1930s reflected the changes taking place throughout the country as it was transformed from a rural agrarian society into an industrialized world power.

The term "Regionalist" was first used to refer to the Southern Agrarians, a group of writers concerned with basic philosophical and sociological questions within the cultural framework of the American South. Both literary and visual Regionalists sought to express their personal responses to a given environment based on direct experience—but not from a reformist stance. (1) Artistic expression of these concerns eventually resulted in a school reflecting a broad regional point of view and, cumulatively, a native art.

Regionalism, as the term is used in this exhibition and essay, refers to a movement of the late 1920s and 1930s which concentrated on local subject matter and themes treated in a representational manner and usually, though not exclusively, reflected a positive view of rural and urban life. Seen in retrospect, Regionalists painted a broad range of subjects, including some scenes implying social commentary. Regionalism, in the broad sense, refers to art which presents personal responses to a given region but transcends regional boundaries to communicate to all Americans.

By the late 1930s, the pendulum of fashion in art was swinging away from American scene painting. Artists and critics began to decry Regionalism as provincial and naively nationalistic. It was blamed for making the people of middle America, who closely identified with the movement, suspicious of modernism. (2) International modernism, reasserting its primacy, forced American Regionalism into disrepute for several decades. In the 1970s, a reassessment of Regionalism began, placing it firmly within the rich and continuing tradition of realism in American art. This reassessment coincided with renewed interest in realism and figurative styles in general.

In the re-examination of California art of the 1930s, historians have generally concentrated on the somber and subdued work of painters like John Langley Howard, which was heightened by strong social consciousness. This trend was influenced by Mexican social muralists like Diego Rivera who worked in California during the early 1930s and inspired a modified form of Social Realism in some of the frescoes and easel paintings completed under the Works Progress Administration.

Although recent studies have discussed these federal art projects, along with social realist and modernist movements of the period, the California school of watercolor that rose to prominence during the Depression

Nelbert Chouinard, founder of the
Chouinard School of Art, ca. 1936.
Courtesy of Robert Perine.

has received little critical or scholarly attention as an independent movement. (3) Yet, because it was the only important regional school of watercolor within the broader context of the American scene, it made a unique contribution to the history of American art. Many of the California artists who enjoyed a national reputation during the 1930s were leading members of the loosely structured movement and first received critical acclaim for their achievements as watercolor artists. Our exhibition explores this particularly rich manifestation of California Regionalism; it attempts to identify some key artists associated with the movement, trace the origin of their artistic concerns, consider their relationship and contribution to the greater American art scene and present a representative cross section of their most characteristic work reflecting Regionalist concerns.

Realistic portrayals of the native scene were not new, either in American or California art. The immediate roots of Regionalism lay in the early-twentieth-century American Realist movement led by Robert Henri known as the Ashcan School; broader influences range from the earliest landscapes in the folk art tradition to those of the Hudson River School.

California's astonishing natural beauty had inspired earlier artists, both residents and visitors. Grand scenes of Yosemite Valley by Albert Bierstadt and Thomas Hill, followed by the intimate tonalist paintings of George Inness and William Keith, were nineteenth-century predecessors of the work of the California Impressionists who became popular in the early twentieth century.

Some of these artists, who worked "en plein air," painted in oil directly on prepared white canvas, often using Neo-Impressionist brushwork. They adopted a flickering brush stroke, applying dabs of contrasting colors to create optically a pleasing atmospheric effect. (4) Many of them used watercolor in the same Impressionist or Post-Impressionist manner. Their work was the conservative expression of modernist art that appeared in California following the 1915 Panama-Pacific International Exhibition in San Francisco.

A younger group of artists became interested in the

California scene in the 1930s. They began painting lively scenes of the uninhabited parts of the state and urban views. Watercolor was ideally suited to the artistic temperament of these artists, who liked to paint outdoors in a direct and spontaneous manner, and many of them began to explore this medium as their chief means of expression. The mild California climate afforded them a year-round opportunity to paint directly from nature.

This interest in watercolor applied to artists throughout the state, but in southern California, beginning about 1927, a spirit of camaraderie among artists inspired a notable cohesiveness of approach. This was the foundation of a school which eventually attracted the attention of art critics both locally and nationally. Some members of this group acquired their interest in watercolor as students at the Chouinard School of Art, (5) and, as members of the Los Angeles-based California Water Color Society, enjoyed opportunities to meet and paint together. They were influenced by their teachers, by whatever impressions reached them from the broader art scene and by the prevailing artistic culture of Los Angeles itself.

Little information about modernist art more recent than Impressionism had reached the Los Angeles area in the late 1920s, and exhibitions of contemporary painting were rare. The public was still loyal to the followers of Impressionism who dominated the local art scene. (6) Chouinard had several teachers who had spent time in Europe and New York and thus were able to give their students some sense of the greater art world while grounding them in the fundamentals of technique. Outstanding among these influential instructors were Clarence Hinkle, F. Tolles Chamberlin, Lawrence Murphy and Carter Pruett. (7)

Clarence Hinkle instilled in his students the spirit of experimentation, teaching them to paint directly from nature, using free Neo-Impressionist brushwork. Chamberlin stressed the importance of capturing the quality of the subject itself, rather than imposing a preconceived style on it. (8) Murphy, who drew incessantly in class, demonstrated the value of developing

Charles Payzant, *Olvera Street,*
1929, watercolor on paper.
Courtesy of Jessie
Shannon-Payzant.

an innate sense of composition without losing natural
spontaneity. Carter, a well-known illustrator, taught the
principles of good illustration—figural observation and
narrative information. (9)

Quite naturally the young artists' approach to
watercolor first reflected their early education with
impressionistic brushwork and a palette of vibrant, often
Fauvist, coloration and sometimes dark, opaque colors.
Their early ventures into realism, inspired by the themes
of the Ashcan School, still showed a stylistic interest in
light and atmospheric effects. Millard Sheets' *Spring Street*
and *Sunset Tenements* are examples of this early phase of
California Regionalism, when artists sought out the
picturesque aspects of city street scenes. Interested in
capturing an "impression" of the whole, they did not
concern themselves with human activity or narrative
possibilities, nor did they evoke a strong sense of a
particular period and place.

The approach to style, subject and theme which
identifies the California artists with the American
Regionalist movement did not appear until the early
1930s. By about 1932, the impressionistic approach to
watercolor had largely been abandoned. (10) Greater
graphic intensity, plasticity and narrative power replaced
the earlier concern with brilliant effects of color and light.
The layering of graduated washes made it possible to
capture quickly the essence of a scene, and the human
figure took on increasing importance. A shift from pure
landscape or cityscape to Regionalist genre painting was
underway. This shift developed naturally as a combination
of the artists' growing awareness of contemporary trends
in the American art world and concern for the social
responsibility of the American artist. The new subject
matter also demanded a fresh appropriate style. A number
of important factors helped shape this new development.

By the late 1920s *Art Digest* and other major art
periodicals had begun to emphasize nationalist concerns
and were giving considerable coverage to painters of the
American scene. (11) Further stimulation came from the
Eastern painter, Edward Bruce, who in 1931 was already
an influential force, particularly in exposing artists to new
ways of seeing their own California landscape. (12) When
Bruce later became director of the Work Progress
Administration, his influence in this direction increased.

The 12th annual juried exhibition of painting and
sculpture at the Los Angeles Museum in 1931 was an
important opportunity for Californians to see the work of
prominent American scene painters Benton, Wood, Curry
and Marsden Hartley. Los Angeles watercolorists Hardie
Gramatky and Charles Payzant won two of the four
awards at the exhibition. (13) Canadian-born Payzant won
his award of merit for a watercolor, *Wilshire Blvd.* This
painting of what was Los Angeles' main street at the time
has some illustrational qualities but is also highly
inventive. Breaking away from his painterly work of the
1920s, Payzant adopts a new approach to watercolor. The
white paper ground defines space and objects; the brush
strokes are broad, with large areas of transparent,
graduated wash—all quite novel at the time. Also new

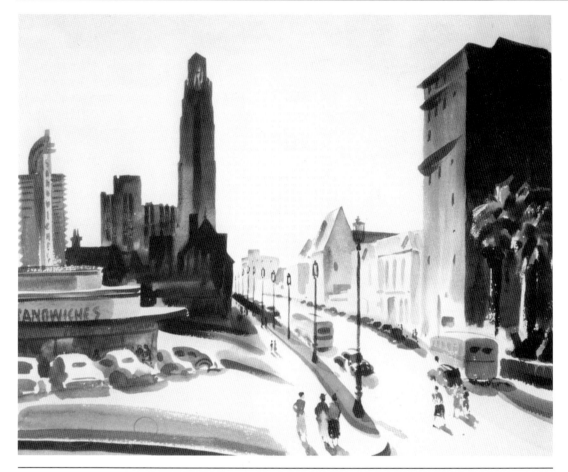

Charles Payzant, *Wilshire Blvd.*,
1931, watercolor on paper.

and as he is joined by other artists, certain selections and eliminations, certain intensifications will inevitably be made. These will, in time, tend toward the formation of an attitude, toward a recognizable trend in observation, sentiment, and even in technique. When these factors are fused into an emotional unity we have the beginning of a school." (14) Mention of the California school began to appear locally in the late 1920s, and by 1934 word of its activities became a regular feature in national art periodicals. The distinguishing characteristics most frequently noted were large format, strong rich colors and bold free brushwork. (15) Their experimental and vigorous approach to watercolor initially grew out of artistic practices like the "plein air" method prevalent at the Chouinard School of Art in the late 1920s and early 1930s. (16) The quality of immediacy in the work of the California artists was most often mentioned by contemporary critics; the subject matter depicted a fascinating region and pattern of life quite different from other parts of the country.

While the senior Regionalists of the Midwest had rejected modernism and the city to move back to a more natural, rural way of life, many of the southern California artists had moved from undeveloped areas around Los Angeles to study and find employment in the urban center. Consequently, the unique character of that city is reflected in the work of many artists in the California school.

In the 1930s, Los Angeles, a politically conservative city of over two million people, was just emerging from a rural past. Thousands of displaced persons from the Dust Bowl poured into the area looking for work in the agricultural and oil industries which were, along with Hollywood's film industry, the occupational mainstays during the Depression. Southern California was like a sprawling city composed of a hundred Midwestern towns, each populated by about ten thousand people and interspersed with farms, ranches and orange groves.

A mutual interest in painting the unusual charms of Los Angeles and the surrounding area led to the development of the California school. In the words of

was the use of recognizable California symbols such as the drive-in and the palm tree. Thus, *Wilshire Blvd.* combines many characteristics of the California school in a lively, confident manner.

During the 1930s, critics began to recognize and comment on the progress of this new and vigorous regional school of watercolor, often calling it "the California school." At a time when America was searching for its own artistic identity, the regional schools stimulated considerable discussion. Writing on the subject in 1939, Holger Cahill said, "As the artist goes on,

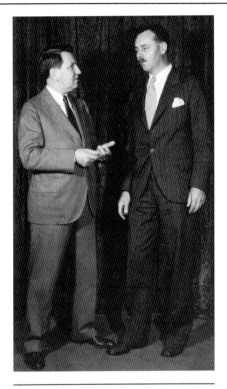

Earl Stendahl and Arthur Millier, Los Angeles, 1930s. Courtesy of Al Stendahl. (Photo: Faxan Photographers)

Merle Armitage, these artists painted "the farms, towns, roads and actual life of which they were a part." (17) Throughout the 1930s, they produced countless images of the area in watercolor. As critic Glenn Wessels observed, "The new angle of their work is their intimate love of what might be called the California scene. If Grant Wood, John Steuart Curry and Thomas Benton have described the Middle West for middle westerners, this group of Californians are describing California in water color for Californians." (18)

In spite of divergent styles that reflected their individual responses, the California artists maintained cohesiveness in a number of ways. During the 1930s and 1940s, art associations and societies throughout the country made important contributions to the growth of regional art, and this was especially true in California.

In 1927 Phil Dike, Millard Sheets, Barse Miller, Paul Sample, Lee Blair, Phil Paradise and Hardie Gramatky joined the California Water Color Society, which promoted interest in the medium and also circulated its members' work in traveling exhibitions nationwide. (19) The friendly competition which the society inspired helped to motivate the energetic young artists. Their exhibitions drew the attention of Arthur Millier, art critic of the *Los Angeles Times,* an etcher and watercolor painter in the English tradition, who took a genuine interest in the accomplishments of the local artists. His weekly page of criticism in the Sunday *Times* helped to advance art and the range of thinking of both artists and public in southern California. As a regular correspondent for the *Christian Science Monitor* and *Art Digest,* he was instrumental in bringing the work of the California school to the attention of the nation. The California Water Color Society hosted annual exhibitions that, like those hosted by eastern groups like the Philadelphia Water Color Club at the Pennsylvania Academy of Fine Arts and by the Art Institute of Chicago, always merited reviews in national publications.

This attention spurred a widespread interest in watercolor in California that spawned ten new watercolor societies within a decade. Though this revival was

nationwide, (20) California showed a precocious interest in the medium and helped to propel the national movement forward. Watercolor was considered a particularly American means of expression whose characteristics were often compared to the national temperament: "The medium's swift fluidity fits our experience and outlook. We go fast. We decide quickly. We may not go deep, but we are not as rooted in an acre or a belief as a European is likely to be." (21)

The watercolor medium had an accessibility that made it seem truly democratic. Watercolors, less expensive than oils both to produce and to exhibit, were sold for reasonable prices. Many watercolor exhibitions included paintings matted but not framed, a practice which facilitated shipment and contributed to the large number of traveling exhibitions. (22)

In 1934 the California Water Color Society began to invite easterners to participate in their annual exhibition. In 1939 important artists from other parts of the country who accepted the invitation included Burchfield, Hopper, Yasuo Kuniyoshi, Reginald Marsh and Andrew Wyeth— clear evidence that the society had gained recognition as an organization of national importance. (23)

As national periodicals reviewed the large public exhibitions, individual artists gained national and international reputations. These exhibitions established a relationship between American artists and their audience. Many of the California Regionalists were an important part of this national phenomenon, exhibiting extensively throughout the country; a number of them eventually became members of the prestigious National Academy of Design. The increasing number of institutions, associations, societies and galleries showing art of all kinds was both a testimony to the country's growing interest in art as a democratic activity and an indication of the artists' success in their search for a role in society.

Millard Sheets was responsible in part for the strong growth of Regionalism in southern California. As early as 1932 critic Arthur Millier called him the best known nationally of current Los Angeles artists. (24) One of the earliest proponents of the movement in California, Sheets

Edward Weston, *Jake Zeitlin,*
Carmel, California, ca. 1931.
Courtesy of Mrs. Jake Zeitlin.

eventually became the teacher, friend and supporter of many of the artists who are represented in this exhibition.

While a student at Chouinard, Sheets, at the suggestion of F. Tolles Chamberlin, began to explore the possibilities of watercolor. Phil Dike, Phil Paradise and Ben Messick followed suit, and a group of students asked Mrs. Chouinard to set up a course. A year and a half after entering the school as a student, Sheets was hired to instruct others in watercolor. (25) He taught many directly and, through his energy and example, gave encouragement to others. (26)

Sheets also organized major exhibitions of art as the director of the art section of the Los Angeles County Fair in Pomona, starting in 1931. These exhibitions provided a stimulus that was both entertaining and educational. They were similar to other populist experiments of the 1930s which sought to bring art to the American people. During the same period Sheets built up an art department at Scripps College around which an art colony developed, a kind of vital local center similar to Grant Wood's Stone City Art Colony near Cedar Rapids, Iowa. (27)

Some Los Angeles gallery owners supported the contemporary art scene. Jake Zeitlin, Dalzell Hatfield, Earl Stendahl and Alexander Cowie all gave exhibitions to local artists. The Depression caused galleries to reduce their activities and some, like Hatfield's which had been a second home to the Chouinard students, were forced to close for an extended period of time or find an alternate means of support. (28) In order to keep his extensive gallery spaces active, Stendahl rented them to local artists for a small fee while also supporting himself by making jigsaw puzzles and confectionary chocolates. (29) Zeitlin was particularly supportive of the watercolor artists. His exhibition announcements usually attracted a steady stream of people. (30) Other galleries that supported the artists were the Ilsley Gallery at the Ambassador Hotel, the Tone Price Gallery on Sunset Strip and the Stanley Rose Bookshop. Although actual sales of art were rare in the first few years of the Depression, by 1935, as the economic situation of the city began to improve, a few watercolor painters, including Lee Blair, Paul Sample and

Barse Miller, were able to sell their work in local galleries. Between 1935 and 1940 Tone Price Gallery, which catered mostly to people in the film industry, often sold out their watercolors shows. (31)

The evolution of Regionalism in California from the late 1920s to 1945 paralleled developments in the larger American art scene, yet also reflected the uniqueness of the region in terms of choice of medium, stylistic approach and subject matter. Despite the variety of personal styles and the range of subject matter, the artists' identification with a time and a place, California of the 1930s, was unmistakable. Watercolor was the medium of choice—directness, rawness, spontaneity, emotion and personal style the shared characteristics—as distinctive as the qualities of California's landscape, weather and its developing urban life.

Landscape was an obvious subject in a state where natural beauty abounded. Many landscapes were realistic renditions that emphasized indigenous California qualities but were highly personal visions. James Patrick's study of a stark gray house, *Untitled,* captures the quality of the cool, gray mist and palm trees while evoking a feeling of quietude and an air of expectancy in the moodiness of the sky and the solitary figures on the porch. Early depictions of the California scene often reflect the sense of stillness to be found in Patrick's watercolors. (32)

Pleasant human interaction, usually set in a landscape, is the subject of many paintings. Nat Levy's *Sunday on the Farm* shows three farmers at rest, surrounded by the windswept trees of the Mendocino coast in northern California. Arthur Lonergan's *Backyard Chatter* portrays the amiable sharing of gossip over a back fence. In these paintings, the setting is of primary importance; an anecdotal interest in human nature is secondary. They are reminiscent of earlier American Scene paintings reflecting nostalgia for a rural way of life —people living in harmony with their environment—that was passing out of existence.

Images of people working on the land were a frequent Regionalist theme. James Fitzgerald's *Spring Plowing* is an ode to the dignity of agricultural activity.

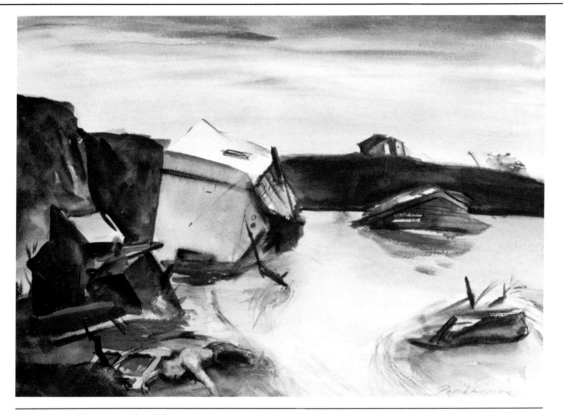

David Levine, *The Victim–Flood of '38* (Los Angeles River), 1938, watercolor on paper.

dramatic rain storm. He uses the improvisational properties of watercolor to excellent advantage, allowing the wet paint to run down the page and blend together to create the effect of a torrential downpour. This highly expressionistic watercolor is a good example of the experimental way in which the California artists approached the medium. (33)

Dike painted *Then It Rained* while on a trip to Arizona in the early 1930s. Although recreational travel was generally curtailed during the Depression, many southern California artists managed to visit old mining and ghost towns of the Southwest and communities on both sides of the Mexican border. Some even went as far as Central and South America.

Recreation was more likely to be pursued closer to home, and in *Balboa Inlet* Barse Miller captures aspects of California life which make the state a tourist mecca. Because watercolors like this, with a sense of immediacy and delight in the moment, were painted in one sitting directly from nature, they are different from the oil paintings and murals of the period, with their more static style or incorporation of historical references. Many artists of the California school were also accomplished oil painters, but contemporary criticism singled out their watercolors as more highly expressive and noteworthy. Although watercolors functioned mostly as independent entities in their oeuvres, the artists sometimes developed them into works on canvas, usually choosing those subjects they felt to have the most power. (34)

In a 1940 review of an exhibition at the Riverside Museum in New York, critic Edward Alden Jewel said, " . . . the water-colors are Western in flavor, nearly all of them characterized by painting traits that have come to be identified with contemporary expression on the Pacific Coast. Among these characteristics, clarity plays an important part. The palette is inclined to be high and fresh. The prevailing mood is decorative—but crisply and boldly so; it isn't just a matter of nice, harmonious color schemes. Much of the work is vigorous in execution, often really expert; and not infrequently it embodies an original point of view . . ." (35)

Fitzgerald was one of a small group of artists on the Monterey Peninsula working in watercolor during the 1930s who, like other artists outside the Los Angeles area, captured the spirit of the Regionalist landscape.

The dramatic qualities of weather conditions also attracted the Regionalists. David Levine, in *Burned Out,* has portrayed the destructive power of nature in a twentieth-century ruin steeped in romantic connotations and heavy with the nostalgia of loss. More powerful still is *The Victim,* produced in response to a scene he witnessed during the flooding of the Los Angeles River in the spring of 1938, a catastrophe in which several people were killed and many left homeless.

In *Corral,* Phil Paradise captures the restless energy of high-strung horses gathering together as a storm threatens. Phil Dike's *Then It Rained* is a masterful evocation of a

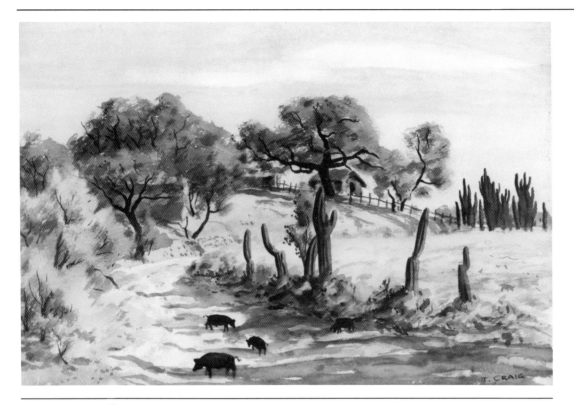

Tom Craig, *Cactus Alley*, watercolor on paper. Courtesy of Susan and Mike Verbal. Probably completed during a painting trip through the Southwest and Mexico while on a Guggenheim Fellowship in 1941. (Photo: Schenck & Schenck Photography)

These individual artistic expressions derived from many sources. Milford Zornes' *Shore at Casmalia* for example evokes a mood of classical allegory. Its looming vertical masses are balanced by the dark stripe of the horizon paralleled by bands in the sky and sand. The monumental rocks overshadow two female figures bathed in the soft light of a misty California beach, creating an air of mystery.

Contemporary criticism often referred to elements of Oriental art in some of these California watercolors. The early work of Zornes, Sheets and Craig showed the influence of both Chinese and Japanese landscape painting (36) and influences from Oriental art, both in color and composition, can also be seen in the work of Nicholas Brigante in *An Accident, Figueroa Street Bridge.*

California artists portrayed the city, like the rural landscape, in all its varying aspects, ranging from quickly observed glimpses of streets, houses and their inhabitants to more closely studied images of city life. Dong Kingman's *San Francisco* suggests the artist's ambivalence about the city. He captivates us with the scene but suggests a sense of despair at the skyscrapers, using distortion and a broad range of colors to evoke a moody, overcast day. Kingman, along with many of the Bay Area scene painters, was more in touch with modernist currents than were his southern California counterparts. In addition, his highly personal style reflects his Chinese-American heritage.

Tom Craig's *Plaza Los Angeles* dramatically expresses the international character of the city during the 1930s. Depicting the downtown area of the city adjoining Olvera Street where Mexican and Asian art and culture were a strong presence, Craig paints a night scene with three flags falling diagonally across the top of the composition to create a striking image.

Like Tom Craig's Los Angeles scene, Millard Sheets' *Beer for Prosperity* recalls Edward Hopper's night paintings of urban dwellers. While Hopper's studies of city life often feature isolated, alienated individuals, Sheets' watercolor is full of life and commemorates the welcome end to Prohibition. (37)

Southern California provided various means for struggling artists to use their talents while earning their livelihood. Many of the California Regionalists not only survived but also achieved a sense of community and purpose through participation in federally sponsored art projects. Although Regionalism was well established both nationally and in California by the time the projects were launched in late December 1934, American scene painting became the "official" government style under the projects. (38)

Federal sponsorship aided artists during the Depression by providing them with monetary support and also the chance to compete for commissions. Millard Sheets was one of fifteen artists chosen to paint murals in the Department of the Interior in Washington in 1936. Other California artists who won important mural

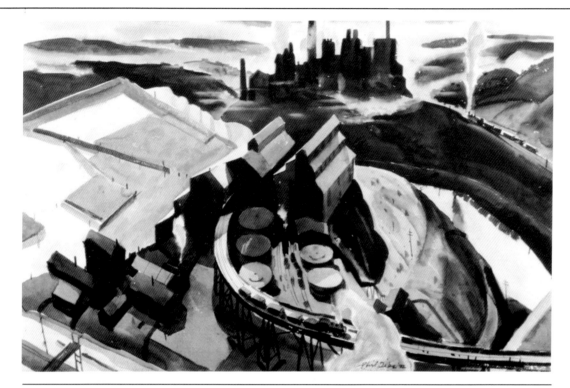

Phil Dike, *Morning, Inspiration Copper*, 1932 (study for the oil painting *Inspiration Copper*), watercolor on paper.

White House. (41) Leadership of the projects included an impressive cross section of California artists. Critic Merle Armitage was the chairman of the Southern California Federal Art Project; Stanton MacDonald-Wright was the director and Lorser Feitelson his assistant. Millard Sheets was made regional director of the project and subsequently organized many of the works undertaken by artists and craftsmen. (42)

Although Los Angeles was hit hard by the Depression, its population, like the rest of the country, rarely waivered from an optimistic faith in the democratic ideal. The film industry helped project this image and contributed to the economic recovery that was felt as early as 1934. (43) Many artists survived the Depression by working in the film industry while they continued to pursue serious careers as artists. They made an important contribution to the aesthetics of film and in return were influenced by the special demands of studio art work.

During the 1930s, Phil Dike was an instructor, color coordinator and story designer for Walt Disney Studios and worked on the animated classics *Snow White* and *Fantasia*. *Band Concert* of 1935, the first Technicolor cartoon, was recognized at the time as a Regionalist cartoon and was widely publicized as a work of high artistic value. (44) Disney's success was due in part to the many creative talents that he found within the artistic community of southern California. Conversely, Dike once explained: "One of the greatest things Disney offers an artist is the discipline of having to sell his stuff by making definite and specific statements in simple, uncomplicated language, pictorially speaking." (45) As seen in *Echo Park*, Dike often infused his figures with a lively spirit, capturing their characteristic behavior with humor and charm.

Hardie Gramatky held an important job in animation at Disney Studios for six years during the 1930s. After a period in the east, he was back in Hollywood during World War II supervising films for the U.S. Air Force and there he painted *Hollywood* in a colorful but dilapidated part of town. He brings the scene to life through the generous use of red and other warm colors to create the effect of California sunlight striking the wall of a market.

commissions for post offices and public buildings included Barse Miller, Fletcher Martin and George Samerjan. Zornes, Sample, Post, Messick, Fitzgerald and Brandt were among those who worked on mural projects sponsored by federal art projects. (39)

Artists were greatly encouraged by the exposure they received for work done under the projects. Many in the watercolor section also gained regional and national recognition when their paintings were circulated among colleges, libraries and high schools and included in museum exhibitions across the country. In 1934, the Los Angeles Museum had a large show of art produced under the Works Progress Administration. (40) California artists received wide acclaim at the Public Works of Art exhibition in Washington the same year. Many works of art from this exhibit, including a watercolor by Zornes, were chosen by President Roosevelt for display in the

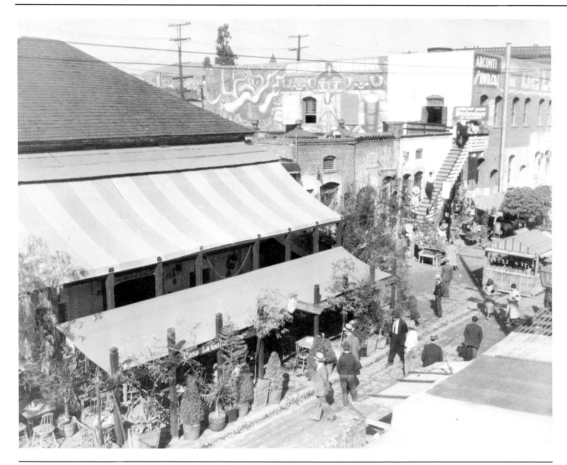

Olvera Street, 1932, showing the mural by David Alfaro Siqueiros, partially whitewashed to hide the mural from the street due to local protest. Courtesy of the *Los Angeles Times* History Center/El Pueblo de Los Angeles Historic Monument.

His illustrations were in demand for publications which often used the work of artists to report on the contemporary scene.

With artists like Thomas Hart Benton, Gramatky was sent on assignment to cover the Mississippi flood in 1937. Benton covered the disaster for Missouri newspapers and then made a lithographic series based on his drawings. On commission for *Fortune* magazine, Gramatky chose watercolor to describe his experience. (46) Paul Sample, Rex Brandt and Millard Sheets also illustrated for this magazine which chronicled the industrial United States in high art fashion, featuring artists of the stature of Burchfield, Marsh, Charles Sheeler and Philip Guston. (47)

Artists readily translated the rapidly changing appearance of California into striking watercolor images. Machines and industrial buildings appear independently or as part of the landscape in the work of several artists; trains were a recurring subject along with the oil derricks that were a common sight from Los Angeles to Santa Barbara. In 1938, Stan Backus visited Hoover Dam and captured what was, at the time, the ultimate symbol of American power and the harnessing of natural forces. Loren Barton painted the steel mill constructed at Fontana by Henry Kaiser during World War II. John Haley's *Gas Eleven-Nine*—painted on location on Wilshire Boulevard—is from his "L.A. Series" containing similar subjects produced in the 1940s. (48) This evidence of the growing industrialization of the state was recorded in a positive spirit by the Regionalists of California.

As the 1930s wore on, nostalgic observations appeared more frequently. In *Close to L.A. Gas Works*, Emil Kosa focuses on a close-up view of a lush green corner of the city juxtaposed with the hazy image of a factory, with cars of the urban transport system visible in the distance. The painting seems to signal the passing of a way of life sacrificed to progress.

Arthur Millier called Dan Lutz, a keen observer of urban life, the "painter-poet of the outmoded and the down-at-heel." (49) In *End of the Line*, Lutz shows trolley car workers with downcast eyes trudging home past the

Lee Blair, *Dissenting Factions,*
watercolor on paper.

parked inter-urban Yellow Cars. The subject would have inspired nostalgia even then, since a campaign to have the cars removed from the streets was already underway.

Living and working in the midst of the daily struggle that was city life in the 1930s, artists naturally became involved with people of all types as well as with the social issues of the day. Ben Messick and Carl Beetz carried on the great tradition of John Sloan in their portrayals of city characters, done with both humanity and humor. In *Negro Pool Hall,* Beetz introduces types well known to him and demonstrates his interest in human physiognomy. (50) Messick found his subjects on the streets, in Pershing Square (51) and on circus lots. He was one of several California Regionalists, in the tradition of Curry and Marsh, who enjoyed depicting the circus, a popular element of American culture. Messick's *Waiting for the Spec* is a colorful glimpse at the behind-the-scenes activities that he found fascinating.

The presence in California of the Mexican muralists Diego Rivera, José Clemente Orozco and David Alfaro Siqueiros had a profound influence on the art of the 1930s, both in stylistic innovation and social consciousness. They believed it was their responsibility to incorporate social issues into their murals in order to speak to humanity with force, clarity and relevance. Many Californians were affected by this attitude and adopted a modified form of Social Realism. This was particularly true in San Francisco where Rivera worked on several murals and where labor management struggles were a daily occurrence.

In 1932, as part of a workshop in fresco technique, a group of artists including Lee Blair, Phil Paradise, Paul Sample, Elmer Plummer, James Patrick, Barse Miller and Millard Sheets assisted Siqueiros in the execution of a mural in the courtyard of Chouinard Art Institute. (52) In addition to learning greater boldness and stylization from Siqueiros, they also acquired a more direct approach to their work. They were encouraged to try new techniques, since experimentation was integral to Siqueiros' mural work. And since both fresco painting and the California approach to watercolor use wet-into-wet (53) techniques

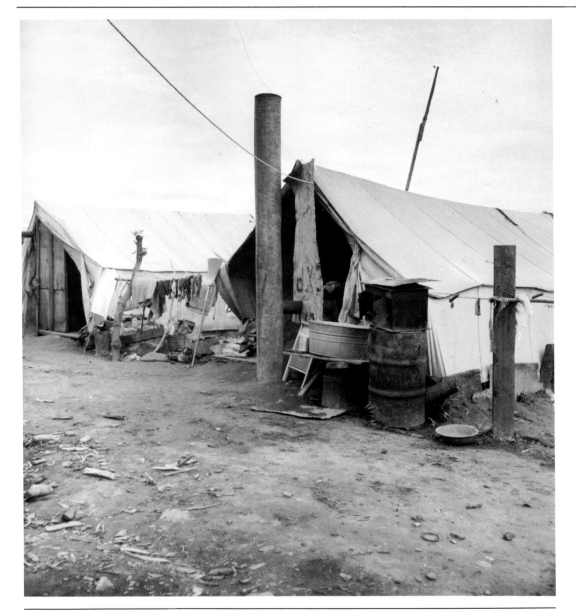

Dorothea Lange, *Cotton Camps,*
San Joaquin Valley, 1937. Courtesy
of The Oakland Museum,
Dorothea Lange Collection.

requiring previsualization of the finished effect and quick, spontaneous rendering, the artists' work in watercolor was also affected. At least two other Siqueiros murals in the Los Angeles area were done with the assistance of other artists of the California school. (54)

Watercolors reflecting the difficult social conditions and the everyday dramas created by widespread poverty occur in the work of California Regionalists, but they are few in number and generally positive in spirit. Artists were acutely aware of prevailing social conditions but not overly reformist in the way they recorded them.

Lee Blair's watercolor *Dissenting Factions* comments on incidents he witnessed during a strike of workers in the film industry. (55) He created a complex composition reminiscent of historical paintings of the French Revolution, with a heroic style unusual in California watercolors of the period. In his *Rain at Box Springs Camp,* Brandt has captured the loneliness of a railroad worker returning to the cook shack and bunkhouse of a construction camp. Inspired perhaps by Charles Burchfield, Brandt conveys a sense of isolation that allows the viewer to identify with the subject. (56) Unlike most visual records of the migrant camps, widespread throughout California during the Depression, Mary Blair's *Okie Camp* does not attempt social commentary. Instead it reflects the artist's unique vision and ironically uses an animated orchestra of shape and color to evoke a touching humanity. Her ability to capture "the slightly cock-eyed aspect of everyday happenings" (57) also made her one of Walt Disney's favorite artists. Far less optimistic is Sheets' *Miggs Ready for the Road,* a poignant depiction of homeless migrant workers. This painting was reproduced to accompany a 1939 article in *Fortune* magazine. (58) In 1941, American citizens of Japanese descent were given short notice to sell or abandon their property before being shipped to relocation camps. George Samerjan witnessed the preliminary arrangements of a Japanese family and recorded it in *Japanese Evacuation, Terminal Island, California.*

World War II provided both the final subject matter for California Regionalism and the conditions which

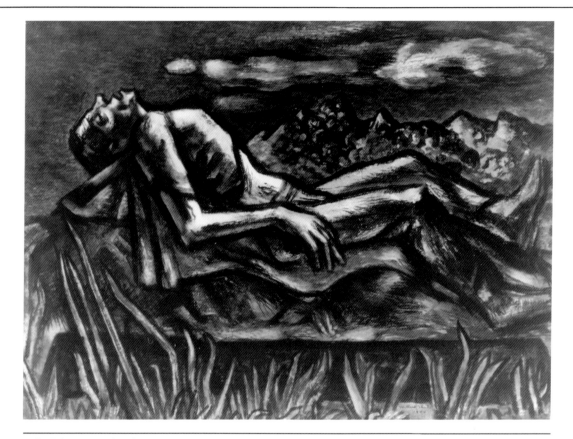

Millard Sheets, *Dead Tank Captain,*
1943, watercolor on paper.
Courtesy of Mr. and Mrs. Millard
Sheets.

ultimately led to the end of its relevance as an artistic movement. The social upheaval of the war years and irresistible new forces in the art world were destined to displace the indigenous movement of the 1930s. Artistic change was inevitable, in keeping with other profound changes in society.

Although some artists continued to produce American scene paintings, the main focus had changed to other concerns. Art exhibitions of war paintings filled galleries across the country, and national periodicals devoted most space to reproductions of paintings interpreting the war.

Previous artists had similarly recorded other wars for the American people. Winslow Homer followed Civil War campaigns for *Harper's Weekly;* William Glackens worked for the same magazine during the Spanish-American War; Remington sketched during the Russo-Japanese War. (59) During World War II, *Life* magazine carried on this tradition by commissioning artists like Millard Sheets, Tom Craig, Fletcher Martin and Paul Sample to record the war effort. (60)

In 1941 *Life* magazine featured the work of seven artists commissioned to paint segments of the national defense scene. Each of the seven, including Barse Miller, Fletcher Martin and Paul Sample, spent three weeks on location, working primarily in watercolor. The paragraph introducing the accompanying article read: "For more than 20 years American artists have been discovering America. Exhaustively and exhaustingly, they have painted its dustbowls and Main Streets, its sharecroppers and Ozark nudes. But today a new period of America brings them a new theme for art. This is the period of national defense." (61)

The United States War Department formed units composed of artists, including Milford Zornes, Stan Backus and Barse Miller—Miller served as chief of the Combat Art Section in the Pacific theater. (62) The works of these artists were reproduced widely in magazines like *Life* and shown throughout the country in exhibitions of war paintings, further establishing their national reputations.

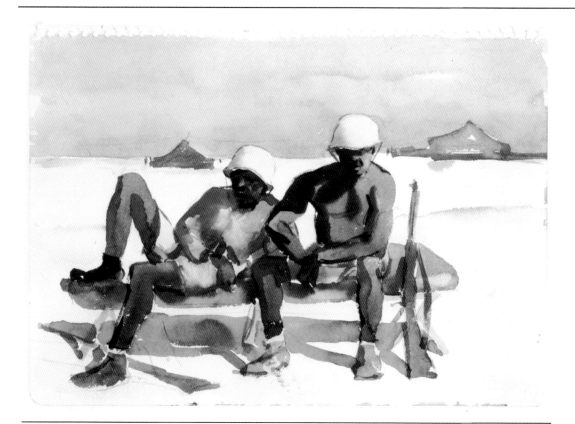

Paul Sample, *Canton Island*, 1943,
watercolor on paper. Courtesy of
the Hood Museum of Art,
Dartmouth College, Hanover, New
Hampshire.

The war experience forced many American artists
into a spiritual revolution, transforming them from
painters of the local scene into seekers for a deeper
meaning and significance to life. Although many
California scene painters retained their Regionalist style
for some years after the 1930s, Miller was one artist
representative of those who did not wish to return to
painting images of the American scene for some time after
he returned from service. (63) His new work was different
—"an agitated network of wiry, calligraphic lines and
furtive blotchy shadows." (64) After World War II, the
Regionalist movement submitted to radically new
developments in American art. The American artist had
discovered his roots and now was prepared to explore
new directions with confidence.

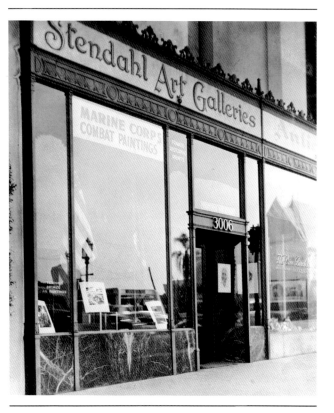

Stendahl Art Galleries, 1942,
exhibition of Marine Corps combat
paintings. Courtesy of Al Stendahl.

NOTES

1. James Dennis, *Grant Wood* (Columbia: University of Missouri, 1986), p. 193.

2. H. W. Janson, "Benton and Wood, Champions of Regionalism," *The Magazine of Art* 39 (May 1945): pp. 183-186.

3. Nancy Dustin Wall Moure examines the school within the context of the California Water Color Society in *The California Water Color Society Prize Winners 1931–1954, Index to Exhibitions 1921–1954* (Glendale: By the author, 935 West Mountain Street, 1975). See also Janet B. Dominik, *The California School: The Private Collection of E. Gene Crain*, exh. cat. (Gualala: Gualala Arts, 1986).

4. Harvey L. Jones, *Impressionism: The California View, Paintings 1890–1930*, exh. cat. (Oakland: The Oakland Museum Art Department, 1981), p. 9.

5. Chouinard School of Art (reincorporated in 1935 as Chouinard Art Institute), founded by Nelbert Chouinard in 1921, developed a national reputation as an art school. It was part of the vital Los Angeles art community centered in Westlake Park, consisting of the Art Center School, Otis Art Institute, the Federal Art Project Art Center, the Foundation of Western Art, Stendahl Galleries, Dalzell Hatfield Galleries, Jake Zeitlin's Bookshop, the Los Angeles Art Association and art supply stores, chief among them Ted Gibson Framers.

The artists lived together in boarding houses in the neighborhood and shared studios near the school. Many regularly gathered in the barn behind the school to work and talk about art. They shared many common interests including "the fundamental problems of aesthetics and meaning of painting, although nobody discussed it in that sense." For the most part they were neither philosophically nor politically inclined. Archives of American Art, Smithsonian Institution, interview with Millard Sheets by Paul Karlstrom on 28 and 29 October 1986, edited draft transcript, p. 40.

6. Winifred Haines Higgins, "Art Collecting in the Los Angeles Area 1910-1960," dissertation, UCLA, 1963, p. 14.

Although they saw the work of Picasso, Matisse, Van Gogh, and even the Blaue Reiter artists at Hatfield and Stendahl Galleries, it was Mexican art that most impressed the students and teachers at Chouinard according to Millard Sheets. This interest had begun in 1930 with the arrival of José Clement Orozco who painted a mural at nearby Pomona College, and it was intensified by the exhibition of Mexican art organized by the Federation of Arts of Los Angeles in 1931.

Southern California Impressionism is commonly referred to as the Eucalyptus School, although the term, when coined by Merle Armitage, originally referred to amateur painters only. Janet B. Dominik, *Early Artists in Laguna Beach: The Impressionists*, exh. cat. (Laguna Beach: Laguna Art Museum, 1986), p. 27.

7. Many of the artists and families of the artists interviewed spoke about the profound influence these teachers had on them. An impressive international array of guest lecturers and teachers also visited the school in the early 1930s, including: Richard Neutra, R. M. Schindler, Morgan Russell, Stanton MacDonald-Wright, Alexander Archipenko and Hans Hoffmann. Robert Perine, *Chouinard: An Art Vision Betrayed* (Encinitas: Artra Publishing, Inc., 1985), pp. 71-75.

8. The artists of the California school subsequently felt strongly that the nature of the subject should dictate style and technique. Their emotional response to the subject was all-important, providing the impetus to paint and guiding their stylistic approach. This attitude accounts for much of the directness and sincerity of the work but also for a general diversity and lack of consistent style sometimes noted in the work of individual artists. Tom Craig expressed this attitude well when he said, "I try to find the means available to the subject at hand . . . The all important element . . . is the mystery of things seen and experienced." Alfred Frankenstein, "Tom Craig's Water Colors," *The Magazine of Art* 31 (October 1938): p. 578.

9. Conveyed in interviews with Millard Sheets, Phil Dike, Mrs. Carl Beetz Bock; Mary Davis MacNaughton, *Art at Scripps: The Early Years*, exh. cat. (Claremont: Scripps College, 1987), p. 8.

10. Arthur Millier, "Millard Sheets Career Seen as Swift Growth." *Los Angeles Times*, 15 May 1932, sec 4, p. 10 .

Millard Sheets began at this time, for example, to make watercolors of farmlands and rolling hills without the broken wash and white flecks (sometimes called 'accidentals') of his previous style and instead used graduated washes. According to him, his choice of subject matter was influenced by Edward Bruce, who was a watercolor painter, and may have also been a source for the new approach.

11. In California, *Art Digest* had twice the circulation per capita of New York, which accounts for the amount of space given to the coverage of California art. Peyton Boswell, "California," *Art Digest* 4 (August 1930): 4. Peyton Boswell, the editor of the magazine, knew many of the watercolor artists personally.

12. "Edward Bruce Shows California How It Looks to Eastern Eyes," *Art Digest* 5 (March 1931): 13; Arthur Millier, "Brush Strokes," *Los Angeles Times*, 15 March 1932, sec. 4, p. 10.

13. "Los Angeles Holds Its Twelfth Annual Show," *Art Digest* 5 (March 1931): 13; "Charles Payzant Wins First Prize With Art Exhibit," *Santa Monica Outlook*, 13 March 1931 ; The Los Angeles Museum of Art, *The Twelfth Annual Exhibition of American Painters and Sculptors*, exh. cat. (Los Angeles Museum Art News, 1931).

14. Holger Cahill, *American Art Today, New York World's Fair*, exh. cat. (New York: National Art Society, 1939), p. 23.

15. Nancy Dustin Wall Moure, *The California Water Color Society Prize Winners 1931–1954, Index to Exhibitions 1921–1954*, p. 2.

16. This idea was introduced to me during an interview with Millard Sheets, 17 January 1988.

17. Dalzell Hatfield, *Millard Sheets* (New York: Dalzell Hatfield, 1935), p. 6.

18. "Twelve California Watercolorists," *Art Digest* 11 (September 1937): p. 13.

19. Nancy Dustin Wall Moure, *The California Water Color Society Prize Winners 1931–1954, Index to Exhibitions 1921–1954*, p. 2.

20. Cyril Kay Scott, "Aquarelle Revival," *Art Digest* 9, November 1934, p. 7.

21. Arthur Millier, "Western Water Colorists Seen in Well-Chosen Show," *Los Angeles Times*, 22 April 1934.

22. Interview with Lee Blair, 27 December 1987.

23. Nancy Dustin Wall Moure, *The California Water Color Society Prize Winners 1931–1954, Index to Exhibitions 1921–1954*, pp. 1-3; Janet B. Dominik, *The California School, The Private Collection of E. Gene Crain*, p. 10.; Arthur Millier, *Los Angeles Times*, 22 October 1939.

24. Arthur Millier, *Los Angeles Times*, 15 May 1932.

25. Interview with Millard Sheets, 17 January 1988.

26. Sheets began to set the pace for the other artists when, on completion of his studies in 1929, he won a national competition and had a one-man exhibition at Dalzell Hatfield's gallery. Overnight Sheets received local critical acclaim and acquired enough funds to travel through South America to Europe. Like many fellow American artists traveling internationally at this time Sheet's taste was largely formed before he went to Europe. As Hatfield said in his 1935 essay on Sheets: "Immediately upon the closing of his exhibition he left for a tour of European museums and art centers, to return six months later with a broader comprehension of the field of art, but uninfluenced by any school or "ism;" he returned just as truly a product of Western America as he left it." Dalzell Hatfield, *Millard Sheets*, pp. 2-3.

While in Europe, Sheets was most impressed with the work of the early Italian Renaissance painters in Florence, J. M. W. Turner's watercolors in London, an exhibition of Winslow Homer's watercolors in New York and Thomas Hart Benton's "America Today" murals at the New School for Social Research in New York. Mary MacNaughton, *Art at Scripps: The Early Years*, p. 7.

In October 1930, *Art Digest* announced that Sheets was the only West Coast artist accepted into the Carnegie International, the largest and most prestigious of the annual exhibitions of oil painting in the United States. Although he had exhibited his watercolors in eastern exhibitions the year before, this was the first time that Sheets gained national recognition and articles on his achievements soon began to appear in *Art Digest*. It was in this same year that Benton, Curry and Wood also began to receive national recognition.

27. Mary Davis McNaughton addresses Sheets' role as a Southern California Regionalist in *Art at Scripps: The Early Years,* pp. 5-10.

28. Interview with Millard Sheets, 17 January 1988.

29. Interview with Al Stendahl, 17 March 1988.

30. Jacob Israel Zeitlin, "Books and the Imagination: Fifty Years of Rare Books," transcript of a tape-recorded interview conducted by Joel Gardner, University of California, Los Angeles, Oral History Program, 1980.

31. Interview with Lee Blair, 27 December 1987.

32. Generally speaking, the work of the artists developed greater looseness and gestural quality over the decade and reflected their growing interest in action or movement.

33. In many ways, the use of watercolor technique as it is sometimes seen in the work of Dike and some of the other artists of the California school, looks ahead to the work of the Abstract Expressionists. Barse Miller, whose work grew increasingly freer as the decade advanced, was an artist who moved easily into the gestural abstraction of the 1940s.

34. Milford Zornes and Rex Brandt mentioned this in interviews. In a 1941 *Life* magazine article featuring the work of the "California school" a number of the works reproduced were oil paintings. Many of the artists received their recognition in watercolor but continued to work and exhibit in oil and did not personally identify themselves as "watercolorists". Critics did not draw a sharp distinction either, so that the identity of the California school as a specifically watercolor phenomenon sometimes becomes blurred.

35. Edward Alden Jewell, "206 Water-Colors of West Exhibited," *New York Times,* 5 March 1940, p. 21.; When the Metropolitan Museum of Art in New York bought nine of the watercolors out of the exhibition, a furor arose, mostly caused by critic Emily Genauer who called the purchase inconsequential, even though she had favorably reviewed the exhibition. (She had also been disapproving of previous museum purchases.) Most of the reviews were favorable, however, and the exhibition proved "once and for all" the importance of the California school. Edward Alden Jewell, "Watercolors," *The New York Times,* 10 March, 1940. Emily Genauer, "Western Watercolors Praised in New York," *Art Digest* 14 (March 1940): p. 7, 26; "Met Recognizes California Watercolorists," *Art Digest* 14 (September 1940); "Questioning the Met," *Art Digest* 14 (September 1940).

36. When Sheets went to teach at Scripps College in 1932, he encountered Hartley Burr Alexander, a philosopher interested in ancient, primitive and Oriental art, and came under his influence. Craig and Zornes were enrolled in Sheets' first year of classes at the college. *Shore at Casmalia* also shows the influence of Russell Flint, the English watercolorist whose work was shown regularly at Zeitlin's Bookshop.

37. *Beer for Prosperity* was painted 11 years before Hopper's oil painting, *Nighthawks,* 1944. Janet Dominik first pointed out this fact to me.

38. Matthew Baigell, *The American Scene: American Painting of the 1930s* (New York: Praeger Publishers, 1974), p. 46.

39. *New Deal Art: California,* exh. cat. (Santa Clara: University of Santa Clara, 1976), pp. 85-107.

40. Arthur Millier, *Los Angeles Times,* 11 March 1934.

41. Interview with Milford Zornes, 15 March 1988.

42. Merle Armitage, "The Public Works of Art Projects," *California Art and Architecture* (February 1934), p. 20.

43. David Gebhard and Harriette Von Breton, *L.A. in the Thirties* (Los Angeles: Peregrine Smith, Inc., 1975), p. 29.

44. Karal Ann Marling, *Wall to Wall America: A Cultural History of Post-Office Murals in the Great Depression* (Minneapolis University of Minnesota Press, 1982), pp. 99-101; *San Francisco Chronicle,* 24 December 1933.

45. "Disney's Dike," *Time,* March 1941, p. 61.

46. *American Artist* 11 (March 1947), p. 38.

47. Philip Beard and Chris Mullen, *Fortune's America: The Visual Achievements of Fortune Magazine, 1930-1965,* exh. cat. (England: University of East Anglia Library, 1985), pp. 1-20.

48. John Haley and Erle Loran were the originators of the Berkeley school of painting that arose in the 1930s and 1940s. They were professors at the University of California, Berkeley, and students of Hans Hofmann. The watercolors that these artists produced exhibited a style (coined as "the Berkeley school" by critic Alfred Frankenstein in the 1930s) that was far more modernist than those of Southern California artists. Thomas Albright, *Art in the San Francisco Bay Area, 1945-1980,* (Los Angeles: University of California Press, 1985), p. 9.

49. Arthur Millier, "Dan Lutz Shows Art of National Stature," *Los Angeles Times,* 18 September 1938.

50. Interview with Mrs. Brigitta Beetz Bock, 16 January 1988.

51. *Ben Messick,* exh. cat. (Redlands: Eclectic Framer and Gallery, 1987), p. 2.

52. Interviews with Millard Sheets, 17 January 1988; and Lee Blair, 27 December 1987.

53. In the fresco technique wet pigment is quickly applied to a wet plaster surface, with one section at a time being completed before the surface can dry, as no changes can be made to the surface of a mural once it has dried. This is very similar to the wet-into-wet watercolor technique, in which artists of the California school excelled. Here, the watercolor medium is applied onto a sheet of paper which has been dampened. (Siqueiros was also using an airbrush to complete the murals and was not using strictly traditional techniques such as were described here.)

54. Shifra M. Goldman, "Siqueiros and Three Early Murals in Los Angeles," *Art Journal* 33, Summer 1974, p. 323; Lester H. Cooke, Jr., *Fletcher Martin* (New York: Harry N. Abrams, 1977), p. 22.

55. Telephone interview with Lee Blair.

56. Rex Brandt, like some of the other artists, mentioned in an interview the influence of Burchfield.

57. *California Arts and Architecture* 57 (November 1940): p. 6.

58. "I Wonder Where We Can Go Now," *Fortune,* April 1939, p. 90.

59. Peyton Boswell, "Fletcher Martin Paints the War in Africa," *Art Digest* 18 (January 1944).

60. Peyton Boswell, "Life Goes On," *Art Digest* 17 (September 1943).

61. "Defense Paintings: *Life* Recruits Major Artists," *Life,* May 1941.

62. "United States Sends Artists to War Front," *Art Digest* 17 (May 1943): p. 13.

63. Ernest W. Watson, "Barse Miller: Painter at the Crossroads," *American Artist* 10 (June 1946): p. 20.

64. *Art Digest* 20 (October 1945).

SELECTED BIBLIOGRAPHY

Albright, Thomas. *Art in the San Francisco Bay Area, 1945–1980.* Los Angeles: University of California Press, 1985.

Archives of American Art, Smithsonian Institution. Interview with Millard Sheets conducted by Paul Karlstrom on 28 and 29 October 1986.

Baigell, Matthew. *The American Scene: American Painting of the 1930s.* New York: Praeger Publishers, 1974.

Baird, Joseph Armstrong, Jr., ed. *From Exposition to Exposition: Progressive and Conservative Northern California Painting, 1915–1939,* exh. cat. Sacramento: Crocker Art Museum, 1981.

Beard, Philip, and Mullen, Chris. *Fortune's America: The Visual Achievements of Fortune Magazine, 1930–1965,* exh. cat. England: University of East Anglia Library, 1985.

Boswell, Peyton, Jr. *Modern American Painting.* New York: Dodd, Mead & Company, 1940.

Cahill, Holger. *American Art Today, New York World's Fair,* exh. cat. New York: National Art Society, 1939.

California White Paper Painters, exh. cat. Fullerton: California State University, 1976.

A Century of Progress Exhibition of Paintings and Sculpture, exh. cat. Chicago: Chicago Art Institute, 1933.

Cherny, Robert W., and Issel, William. *San Francisco: Presidio, Port and Pacific Metropolis.* San Francisco: Boyd & Fraser Publishing Company, 1981.

Cooke, H. Lester, Jr. *Fletcher Martin.* New York: Harry N. Abrams, Inc., 1977.

Corn, Wanda M. *Grant Wood: The Regionalist Vision,* exh. cat. New Haven and London: Yale University Press, 1983.

"Defense Painters, *Life* Recruits Major Artists." *Life,* July 1941, p. 60.

Dennis, James. *Grant Wood.* Columbia: University of Missouri Press, 1986.

Dominik, Janet B. *The California School: The Private Collection of E. Gene Crain,* exh. cat. Gualala: Gualala Arts, 1986.

Gebhard, David, and Von Breton, Harriette. *L.A. in the Thirties, 1931–1941.* Los Angeles: Peregrine Smith, Inc., 1975.

"George Post, A California Watercolorist," an oral history conducted in 1983 by Ruth Teiser, Regional Oral History Office, Bancroft Library, University of California, 1984.

Goldman, Shifra M. "Siqueiros and Three Early Murals in Los Angeles." *Art Journal* 33 (Summer 1974): pp. 321—27.

Hailey, Gene, ed. *California Art Research Monographs.* San Francisco: Works Progress Administration, 1937.

Haletsky, John T. *Paul Sample: Ivy League Regionalist,* exh. cat. Miami: The Lowe Art Museum, 1984.

Hall, W. S. *Eyes on America.* New York: Studio Publications, Inc., n.d.

Hatfield, Dalzell. *Millard Sheets.* New York: Dalzell Hatfield, 1935.

Heller, Nancy, and Williams, Julia. *Painters of the American Scene.* New York: Galahad Books, 1982.

Higgins, Winifred Haines. "Art Collecting in the Los Angeles Area, 1910—1960," dissertation, UCLA, 1963.

Hopkins, Henry T. *Painting and Sculpture: The Modern Era,* exh. cat. San Francisco: San Francisco Museum of Modern Art, 1976.

Impressionism: The California View, Paintings 1890–1930, exh. cat. Introduction by Harvey L. Jones. Oakland: The Oakland Museum Art Department, 1981.

Janson, H. W. "Benton and Wood, Champions of Regionalism," *The Magazine of Art,* 39, (May 1946).

Kuspit, Donald B. "Regionalism Reconsidered," *Art in America* LXIV, 4 (July 1976).

"Los Angeles Art Community: Group Portrait—Millard Sheets," transcript of a tape-recorded interview by George M. Goodwin, University of California, Los Angeles, Oral History Program, 9 February 1977, 2 vols.

McClelland, Gordon T., and Last, Jay T. *The California Style.* Beverly Hills: Hillcrest Press, Inc., 1985.

MacNaughton, Mary Davis. *Art at Scripps: The Early Years,* exh. cat. Claremont: Scripps College, 1987.

Marling, Karal Ann. *Wall to Wall America: A Cultural History of Post-Office Murals in the Great Depression.* Minneapolis: University of Minnesota Press, 1982.

Millier, Arthur. "New Developments in Southern California Painting." *The American Magazine of Art* (May 1934).

Moure, Nancy Dustin Wall. *Index of Southern California Artists' Clubs and their Exhibitions.* Los Angeles: By the author, 1974.

————. *The California Water Color Society Prize Winners 1931–1954, Index to Exhibitions, 1921–1954.* Glendale: By the author, 935 West Mountain Street, 1975.

————. *Painting and Sculpture in Los Angeles, 1900–1945,* exh. cat. Los Angeles: Los Angeles County Museum of Art, 1980.

————. *Drawings and Illustrations by Southern California Artists before 1950,* exh. cat. Laguna Beach: Laguna Beach Museum of Art, 1982.

————. *Dictionary of Art and Artists in Southern California before 1930.* Glendale: By the author, 935 West Mountain Street, n.d.

New Deal Art: California, exh. cat. Santa Clara: University of Santa Clara, 1976.

O'Connor, Francis V., ed. *Art for the Millions: Essays from the 1930s by Artists and Administrators of the WPA Federal Art Project.* Boston: New York Graphic Society Ltd., 1975.

Orr-Cahall, Christina. *The Art of California: Selected Works from the Collection of The Oakland Museum.* Oakland: Chronicle Books, 1984.

Pagano, Grace. *Contemporary American Painting.* Introduction by Donald Bear. New York: Duell, Sloan and Pearce, 1945.

"The Painters Interpret the War," *Fortune,* March, 1943.

Painting and Sculpture: The San Francisco Art Association. Berkeley: University of California Press, 1952.

Perine, Robert. *Chouinard: An Art Vision Betrayed.* Encinitas: Artra Publishing, Inc., 1985.

Rose, Barbara. *American Painting: The Twentieth Century.* New York: Rizzoli, 1986.

Scott, Cyril Kay. "Aquarelle Revival." *Art Digest* 9 (November 1934): 7.

Seavey, Kent. *Monterey: The Artist's View, 1925–1945.* Monterey: Monterey Peninsula Museum of Art, 1982.

Southern California Artists, 1980–1940, exh. cat. Introduction by Carl Dentzel. Laguna Beach: Laguna Beach Museum of Art, 1979.

Southern California School of Watercolor, 1928–1978, exh. cat. Laguna Beach: Laguna Beach Museum of Art, 1978.

Spangenberg, Helen. *Yesterday's Artists on the Monterey Peninsula.* Monterey: Monterey Peninsula Museum of Art, 1976.

Two Hundred Years of Watercolor Painting in America, exh. cat. New York: Metropolitan Museum of Art, 1967.

Westphal, Ruth. *Plein Air Painters of California: The Southland.* Irvine: Westphal Publishing, 1982.

Whitaker, Frederic. "Watercolor in California," *The American Artist* 32 (May 1968): 37.

CATALOGUE

Artists' Biographies

Compiled by Susan M. Anderson

All dimensions are in inches; height precedes width. Measurements refer to actual image size unless otherwise indicated.

LEON AMYX

Born 20 December 1908
in Visalia, California

Leon Kirkman Amyx graduated from San Jose State College in 1931 and subsequently studied with Henry Lee McFee, Millard Sheets, Leon Kroll, Clarence Hinkle, Henry Chapin, and Erle Loran. He attended Mills College, the University of California at Berkeley, California College of Arts and Crafts, and the Claremont Graduate School, from which he received an M.A. in 1942.

Amyx settled in Monterey County in 1931 and began to paint rural scenes of the Salinas Valley, using both watercolor and oil. By 1935 he was exhibiting in the San Francisco Bay Area and participated in the Golden Gate Exposition, Treasure Island, in 1939. He exhibited with the American Watercolor Society at the National Academy in 1942 and with the National Watercolor Society in New York in 1946. His work traveled throughout Latin America in 1944 as part of a group exhibition organized by the San Francisco Museum of Art. He began exhibiting with the California Water Color Society in 1945.

Amyx taught painting, design, and the history of art at Hartnell College in Salinas in 1936. Although it remained his teaching base until 1972, he taught summer sessions at other institutions including Sacramento State College, San Jose State College, University of the Pacific, and the Claremont Graduate School. On sketching tours of Europe, Amyx has made special study of ancient and medieval architecture.

Amyx is a member of the National Watercolor Society and the Carmel Art Association. He is an honorary member of the Laguna Beach Art Association and an associate of the American Watercolor Society. He won a silver medal at the Oakland Art Gallery in 1944 and first prize at the Monterey County Fair in 1949.

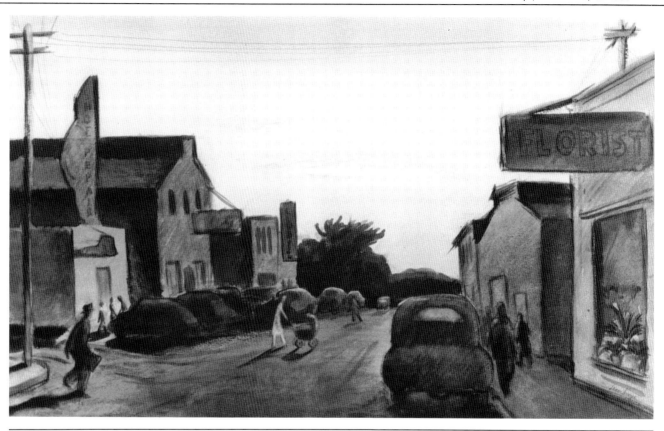

East Salinas, ca. 1939
Watercolor on paper
16¾ x 28
Lent by Chaffee Community
Art Association

STAN BACKUS

Born 5 April 1910
in Detroit, Michigan

Standish Backus, Jr. studied at Princeton University and at the University of Munich, concentrating on architecture. While at Princeton he began painting in watercolor. Although he never had any formal art training, he studied watercolor with Eliot O'Hara for a short time in the mid 1930s, while on his honeymoon in Maine.

In 1935 he moved to Santa Barbara and opened a studio. Though he first worked on his own, he soon made the acquaintance of the watercolor painters Barse Miller, Hardie Gramatky, Emil Kosa and Millard Sheets. By 1938 he was exhibiting in local and regional exhibitions sponsored by institutions and organizations like the California Water Color Society, the Los Angeles Museum, and the Oakland Art Gallery. In 1939 he participated in the Golden Gate International Exposition and in 1940 at the Chicago Art Institute.

During World War II, Backus served as an officer in the U.S. Navy and in 1945 was hired as an official Navy combat artist working in Japan and in the Pacific theater. His duties included recording the effects of the bombing on Hiroshima.

From 1955 to 1956 Backus was commissioned as the official off-Navy artist on Admiral Byrd's expedition to the South Pole. In 1967 he produced the Pacific War Memorial mosaic mural for Corregidor Island, Manila Bay, Philippines. He also created a mural for Beckman Instruments, Inc. in 1955.

Among his awards are a prize, Oakland Art Gallery (1939), and a purchase award, California Water Color Society (1940). He is a member of the American Watercolor Society, the National Watercolor Society, and the American Federation of the Arts.

Hoover Dam, 1938
Watercolor on paper
15 x 22
Collection of Mr. and Mrs.
Michael Rupp

San Bernardino Trainyard
1938
Watercolor on paper
15 x 22
Collection of Glen Knowles

Selz Brothers' Circus, 1938
Watercolor on paper
15 x 22
Collection of Glen Knowles

Santa Marguerita Grade
1939
Watercolor on paper
15 x 22
Lent by Gordon and Debi
McClelland

Untitled, 1939
Watercolor on paper
14½ x 21½
Lent by Gary Breitweiser

*Palm Avenue, Santa
Barbara,* 1940
Watercolor on paper
15 x 22½
Lent by Daphne B. Wood

Uninhabited, 1940
Watercolor on paper
15⅜ x 22⅜
Lent by Los Angeles County
Museum of Art, California
Water Color Society Collection
of Watercolor Paintings
Purchase Award, 1940

LOREN BARTON

Born 16 November 1893
in Oxford, Massachusetts
Died in 1975

Loren (Roberta) Barton Miller was born in the home of her great-aunt, Clara Barton, the founder of the American Red Cross. She moved to the West Coast as a child. At the age of 16, she graduated from the University of Southern California, where she studied under William L. Judson, and later studied at the Art Students League in Los Angeles with Rex Slinkard. Already distinguished as a promising young artist in the 1920s, she had her first one-woman show at the Los Angeles Museum of History, Science and Art in 1920.

From 1929 to 1937, Barton lived primarily in Europe and New York, although she returned briefly to Los Angeles in the autumn of 1930 and continued to show her work in galleries there. In New York during this period Barton began to illustrate books, among them *The Little House*. In 1937 she returned to Los Angeles, where she taught watercolor classes for many years at Chouinard Art Institute and lectured widely in various universities and organizations.

Barton began exhibiting with the California Water Color Society in 1924 and continued to do so until the mid 1950s. She was the recipient of many awards including the Joan of Arc Silver Medal, National Association of Women Painters and Sculptors, New York (1926); the George A. Zabriskie Prize, American Watercolor Society (1941); and the purchase prize, California Water Color Society (1945).

Forest Christening
ca. 1942
Watercolor on paper
21⅛ x 29
Lent by Pomona College,
Claremont, California
Gift of Loren Barton
Miller Estate

Untitled
Watercolor on paper
22 x 30
Lent by Pomona College,
Claremont, California
Gift of Loren Barton
Miller Estate

CARL BEETZ

Born 25 December 1911
in San Francisco, California
Died in 1974

Carl Hugo Beetz was a painter, etcher, and lithographer. In 1930 he studied in New York at the Art Students League with George Bridgman and at Grand Central Art School with Grant Reynard, who introduced him to the work of Daumier, Millet, and other French masters of the 19th century. He also studied at the California School of Fine Arts in San Francisco with Spencer Macky and Ray Bertrand.

James Swinnerton encouraged Beetz to draw in the streets and to study illustration with Pruett Carter. In 1931 Beetz entered the Chouinard Art Institute where he remained for four years, studying with Carter and Lawrence Murphy. In September 1935, he began teaching life drawing there, remaining for nine years. During this period he did illustrations for *Westways* and *Script*, traveled to Europe, and began to work in lithography. He joined the California Water Color Society in 1937 and was an active member until 1944 when he moved to San Francisco. There he taught simultaneously for many years at the California College of Arts and Crafts in Oakland, the Academy of Advertising Art, and the City College of San Francisco. He became a member of the California Society of Etchers in 1954.

During the 1930s and 1940s Beetz participated in local and regional exhibitions at institutions and organizations throughout California, and in annuals sponsored by national art institutions and organizations like the Art Institute of Chicago, the Riverside Museum in New York, and the Philadelphia Print Club. Among other honors, Beetz received first prize from the Redlands Art Guild (1941) and a prize from the California Water Color Society (1943).

Jockey and Judge, 1938
Colored ink on paper
27 x 25
Lent by Brigitta Beetz Bock

Negro Pool Hall, 1938
Colored ink on paper
22½ x 26½
Lent by Brigitta Beetz Bock

Hallway
Mixed media on paper
26 x 15
Lent by Brigitta Beetz Bock

White Sox
Watercolor on paper
24½ x 20
Lent by Brigitta Beetz Bock

33

LEE BLAIR

Born 1 October 1911
in Los Angeles, California

Lee Everett Blair attended the Chouinard Art Institute on a scholarship from 1931 to 1934. There he studied with Morgan Russell, Pruett Carter, and Lawrence Murphy and learned fresco technique from David Alfaro Siqueiros. Later, from 1947 to 1950, he studied at the Art Students League in New York.

In his first year at Chouinard he joined the California Water Color Society and soon began to organize their traveling exhibitions. In 1934, at the age of 23, he was made president of the society. In 1932 he won a gold medal for a watercolor he submitted to the art division of the Olympic Games, hosted that year by the city of Los Angeles.

After graduation from Chouinard, he and his wife Mary, whom he had met at the school, exhibited their work in joint exhibitions at the Ilsley Studio in the Ambassador Hotel. He also exhibited at the Tone Price Gallery on Sunset Strip while working as an animator at U.B. Iwerk's studio and at Harman-Ising Studios (MGM). During the late 1930s he worked at Disney Studios, where he taught life drawing and became a director of color and animation working on features like *Pinocchio* and *Fantasia*. From 1938 to 1939 Lee and Mary traveled to South America on a goodwill sketching tour sponsored by Nelson Rockefeller. Upon their return, Lee taught landscape painting at Chouinard until 1942. After finishing his commission to serve in the Naval Bureau of Aeronautics in 1946, Blair moved with his wife to New York where he directed his own production company, Film Graphics, Inc.

In 1968 the Blairs moved back to Northern California. He taught film animation at Cabrillo College in Aptos from 1975 to 1979 and at the University

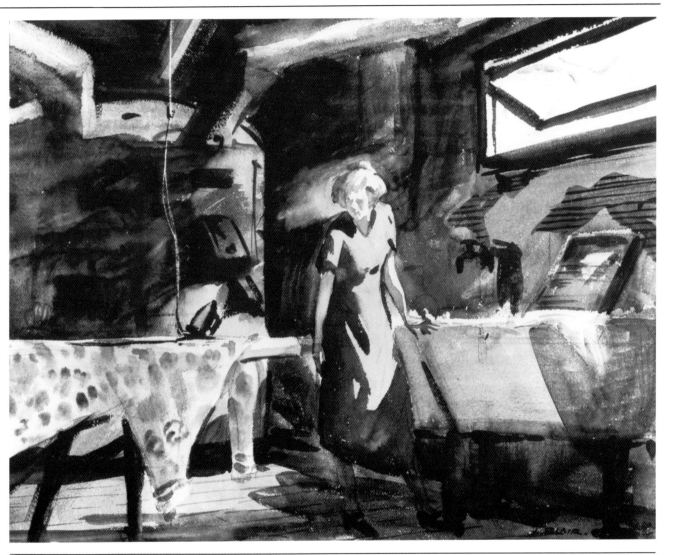

of California, Santa Cruz, beginning in 1977. Blair received many prizes from organizations on the regional and national level, including the California Water Color Society (1933 and 1939) and the American Watercolor Society (1933). Among the many honors bestowed upon him was the prestigious Dolphin Fellowship from the American Watercolor Society.

Eucalyptus School
ca. 1934
Watercolor on paper
15 x 22
Lent by the artist

Washer Woman, 1936
Watercolor on paper
16 x 20
Lent by Gordon and
Debi McClelland

Untitled, 1937
Watercolor on paper
14½ x 21½
Lent by Nancy Dustin
Wall Moure

Evening Star, ca. 1938
Watercolor on paper
16½ x 20½
Lent by John and Nancy Weare

*Pacific Coast Narrow
Gauge*, 1938
Watercolor on paper
16 x 21
Lent by Gordon and Debi
McClelland

Dissenting Factions
Watercolor on paper
15 x 28½
Lent by John and Nancy Weare

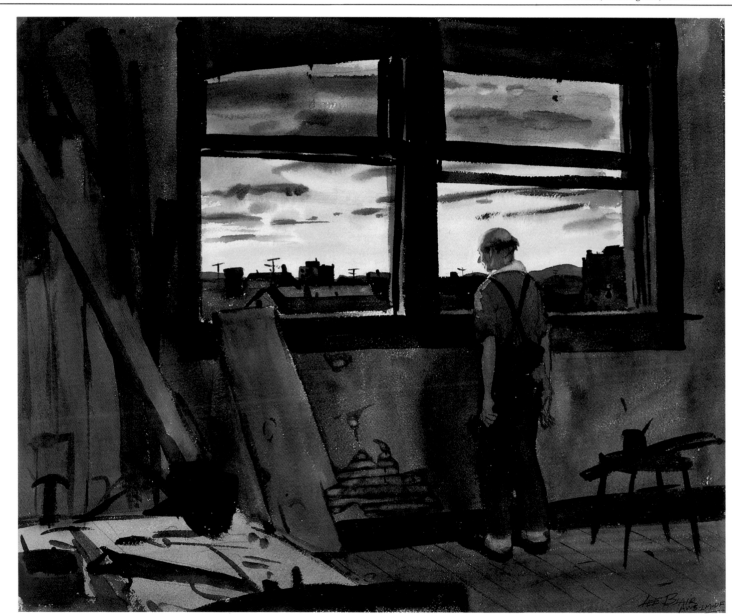

MARY BLAIR

Born 21 October 1911
in McAlister, Oklahoma
Died in 1979

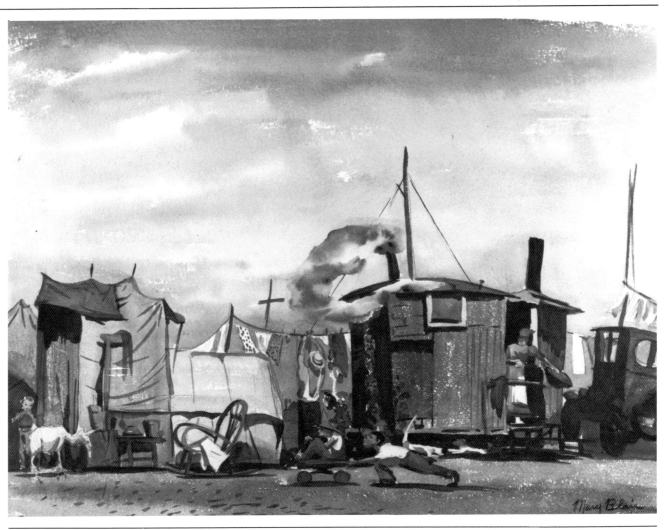

When she was seven years old, Mary Robinson Blair moved to California with her family. She began her education with Daniel Mendelowitz at San Jose State College and then attended Chouinard Art Institute on scholarship from 1930 to 1933, where she studied with Pruett Carter, Lawrence Murphy and Don Graham.

Blair exhibited regularly with the California Water Color Society beginning in 1935, and in joint exhibitions with her husband, Lee, at the Ilsley Studio in the Ambassador Hotel. From 1936 to 1937 she worked at MGM Studios as a color director. In 1939 she moved to Walt Disney Studios and throughout the war worked as a story-sketch artist and color director on productions like *Cinderella* and *Sleeping Beauty.* From 1938 to 1939 Mary and Lee went to South America on a goodwill sketching tour sponsored by Nelson Rockefeller where she gathered material for future features.

In 1946 Blair moved to New York with her husband and started working as a freelance commercial artist. She continued with Disney, flying back and forth between coasts, working on various features and designing attractions for Disneyland. She designed Small Worlds for UNICEF, first seen in 1964 at the New York World's Fair in Flushing Meadows and later moved to its permanent site at Disneyland in Los Angeles, where she also designed murals for Tomorrowland. In addition, she was a successful illustrator and designer of Broadway stage sets.

After moving back to California in 1968, Blair was commissioned to design a tile mural for the Contemporary Hotel in Orlando, Florida. Ten stories high, it is the biggest indoor tile mural in the world.

Church at Balboa Island
1933
Watercolor on paper
15 x 22
Lent by Gordon and Debi McClelland

Okie Camp, 1933
Watercolor on paper
18 x 22
Lent by Lee Blair

San Francisco Night
1933
Watercolor on paper
18 x 22
Lent by Lee Blair

*Balboa Island Ferry Storm,*1934
Watercolor on paper
18 x 22
Lent by Lee Blair

REX BRANDT

Born 12 September 1914
in San Diego, California

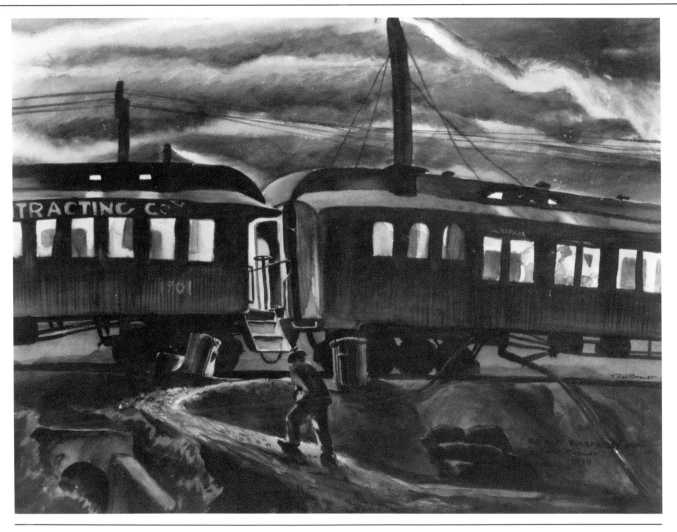

Rexford Elson Brandt was born and raised in Southern California and received his early art training in Saturday classes at Chouinard Art Institute in 1928. In 1936 he graduated from the University of California, Berkeley, where he studied with John Haley, Ray Boynton, Eugen Neuhaus, Perham Nahl, and Margaret Peterson. He pursued post-graduate studies in 1938 at Stanford University and at Redlands University in 1939.

While at Berkeley, Brandt was introduced to early Chinese landscape painting and Byzantine art as well as to the contemporary masters Picasso and Matisse. Under the influence of the legacy left behind by Hans Hoffman, he began to experiment with abstraction.

Upon his return to Southern California, Brandt began exhibiting with the California Water Color Society and became associated with the WPA, acting as director of the project in Riverside and San Bernardino—Imperial counties. In connection with the project, he executed watercolors, lithographs, and murals. In 1937 he and Lawson Cooper organized a traveling exhibition of watercolor paintings called "The California Group." This exhibition created much interest in the California watercolor school.

In the 1930s Brandt began his distinguished career as an educator. Throughout the years he has taught at numerous Southern California institutions like the University of Southern California, the San Diego Fine Arts Gallery, Riverside Junior College, Scripps College, and Chouinard Art Institute, as well as the University of Vermont. In 1947 he and Phil Dike opened the Brandt-Dike Summer School of Painting, which they operated

together through 1955. Afterwards Brandt ran it alone as the Rex Brandt Summer School or the Brandt Painting Workshop until 1985. In 1949 he wrote the first of many books on painting.

Brandt has received many awards including first prize, California Water Color Society (1938); the Samuel F. B. Morse Medal, National Academy of

Design (1968 and 1970); and the bronze medal, American Watercolor Society (1970). He is a Dolphin Fellow of the American Watercolor Society, an honorary life member of the National Watercolor Society, and a life fellow of the Royal Society of the Arts. In 1974 he was elected a member of the National Academy of Design.

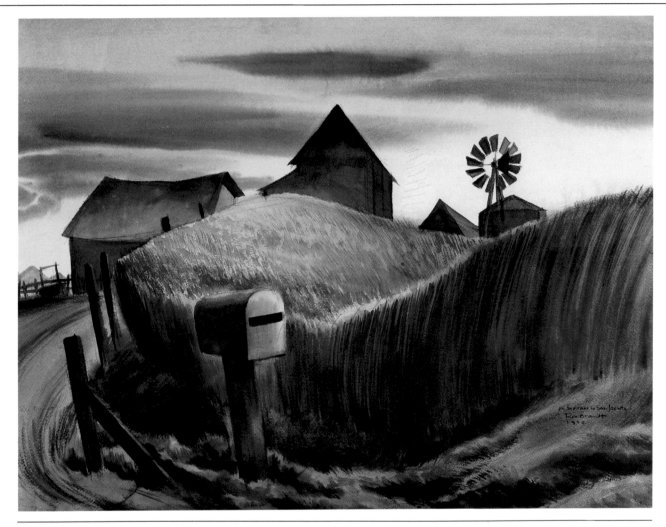

Afternoon at Kellers
1935
Watercolor on paper
16¼ x 18½
Lent by The E. Gene Crain
Collection, Laguna Beach,
California

On the Road to San Jacinto
1938
Watercolor on paper
21¾ x 29¼
Lent by The E. Gene Crain
Collection, Laguna Beach,
California

Rain at Box Springs Camp
or *Evening at Box Springs Camp*
1938
Watercolor on paper
22½ x 30
Lent by Joan Irving Brandt

South San Diego, ca. 1938
Watercolor on paper
21⅝ x 29
Lent by Los Angeles County Museum
of Art, California Water Color Society
Collection of Watercolor Paintings
Purchase Award, 1938

Storm, 1944
Watercolor on paper
19 x 27¾
Lent by Chaffey Community
Art Association

Summer at 29th Street, 1945
Watercolor on paper
22⅝ x 30¼
Lent by Los Angeles County Museum
of Art, California Water Color Society
Collection of Watercolor Paintings
Museum Association
Purchase Award, 1945

NICK BRIGANTE

Born 29 June 1895
in Padula, Italy

Nicholas P. Brigante was raised in Los Angeles after emigrating with his family at the age of two from Italy. At the age of sixteen he learned billboard painting from Hanson Puthuff. Later he went on the road throughout the United States and Canada, painting signs for Coca-Cola, Bull Durham tobacco, and Spearmint gum. After that trip in 1913 he entered the Los Angeles Art Students League where he became friends with the director and instructor Rex Slinkard. He began painting in watercolor in 1917, the same year he joined the army.

Beginning in 1923, Brigante exhibited in group shows in New York that included Charles Demuth, John Marin, Thomas Hart Benton and Andrew Dasburg. In Los Angeles that same year he exhibited his watercolors as a member of the Group of Independent Artists, which organized an exhibition of pioneer modernist painters, including Thomas Hart Benton, Stanton McDonald-Wright, Lawrence Murphy, Morgan Russell, Peter Krasnow, and Rex Slinkard.

In the 1930s, Brigante sought to raise the status of watercolor painting to that of oil painting. He painted a nine-panel watercolor, twenty-one feet in length, which was exhibited at Stendahl Gallery in 1939 and at the Santa Barbara Museum of Art in 1942. Called *Nature and Struggling Imperious Man*, this work set Brigante apart as an artist who synthesized his interests in Chinese scroll painting, abstraction, and realistic figuration into an original narrative mural. He exhibited continuously as a member of the California Water Color Society, from 1931.

Later Brigante eliminated much of the representational element from his art in favor of abstraction, first experimenting with "automatic" drawings incorporating collage. In the 1950s he accentuated the calligraphic and atmospheric elements that had always been apparent in his work.

An Accident, Figueroa Street Bridge, 1936
Watercolor on paper
30½ x 23
Lent by The Memorial Pathology Medical Group, Inc.
Courtesy Tobey C. Moss Gallery, Los Angeles, California

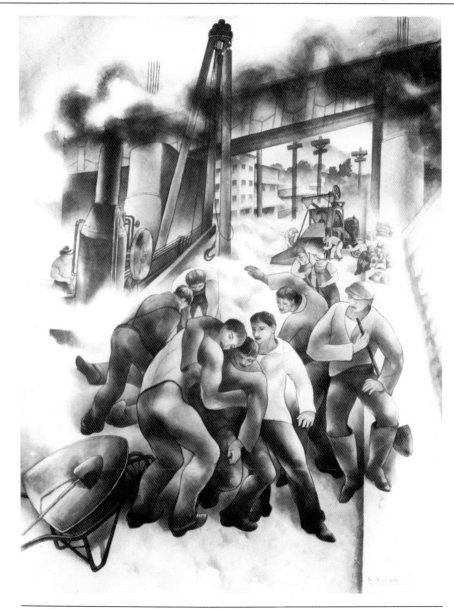

CLAUDE COATS

Born 17 January 1913
in San Francisco, California

Claude Coats was raised in Los Angeles. In 1934 he graduated from the University of Southern California, where he studied with Dan Lutz and Paul Sample. Under Sample's influence, Coats became interested in watercolor and joined the California Water Color Society while still a student. He then went to Chouinard Art Institute for further instruction in the medium with Millard Sheets. While at USC, Coats also learned fresco technique and completed several murals around the college campus.

After completing his studies in 1935, Coats was hired by Phil Dike at Walt Disney Studios as a background painter and color stylist. He worked on many of the animated classics including *Snow White, Pinocchio,* and *Fantasia.* For a few years, he painted watercolor backgrounds, then changed to acrylics. *Snow White* and *Pinocchio* were completed in watercolor.

Coats' early watercolors were of dilapidated buildings, back alley scenes, and celebrative subjects like circuses. As he progressed with Disney Studios, even the watercolors he made in his spare time reflected impressions for his scenic work. He began to move away from the medium after 1945.

In 1955 Coats was hired by Disney to design attraction concepts for Disneyland like Pirates of the Caribbean and Mickey Mouse. He also worked on numerous attractions for Disney World in Florida.

In 1934 Coats received awards for his watercolors from the Los Angeles Museum of History, Science and Art and National Scarab Sketch.

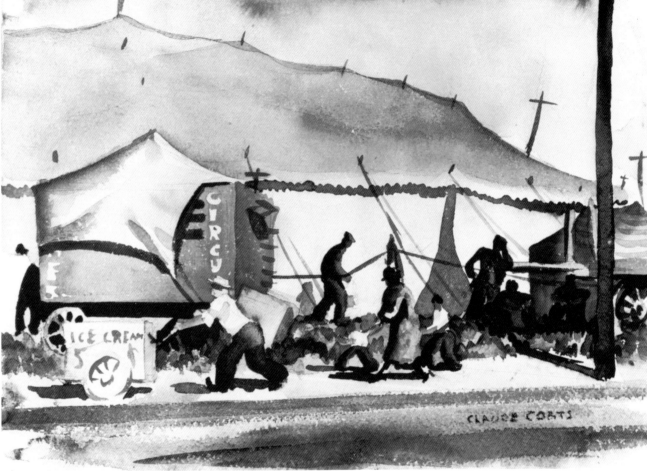

Circus, ca. 1939
Watercolor on paper
11 x 15
Lent by Gordon and
Debi McClelland

SAM COLBURN

Born 9 March 1909
in Denver, Colorado

Samuel Bolton Colburn grew up in Los Angeles and studied geology at the University of Southern California. After graduating in 1932 he went to Europe, where he spent a year traveling and studying art. Upon his return to Los Angeles, he took life drawing with Don Graham at Chouinard Art Institute and met Phil Dike and Millard Sheets.

In 1937 he began to express himself almost exclusively in watercolor. He moved to Carmel, California, the same year, continuing his studies by taking a few lessons in watercolor from Paul Whitman. He became a member of the Carmel Art Association in 1940 and has since been an active member of the artistic community on the Monterey Peninsula, giving classes in painting, executing murals in public places, and exhibiting regularly in local galleries. In addition, he has had one-man exhibitions in New York, San Francisco, Tucson, and at the Santa Barbara Museum of Art.

Over the years, Colburn has received many awards at the Monterey County Fair and, in 1947, at the California State Fair in Sacramento. His portrait of poet Robinson Jeffers is on the cover of the Vintage paperback *Selected Poems*. In addition, his drawings have been reproduced in the *Monterey Peninsula Herald*.

Bodie, 1939
Watercolor on paper
21 x 28
Lent by the artist

In the Vat, ca. 1940
Watercolor on paper
10½ x 15
Lent by William A. Karges
Fine Art

TOM CRAIG

Born 16 June 1907
in Upland, California
Died in 1969

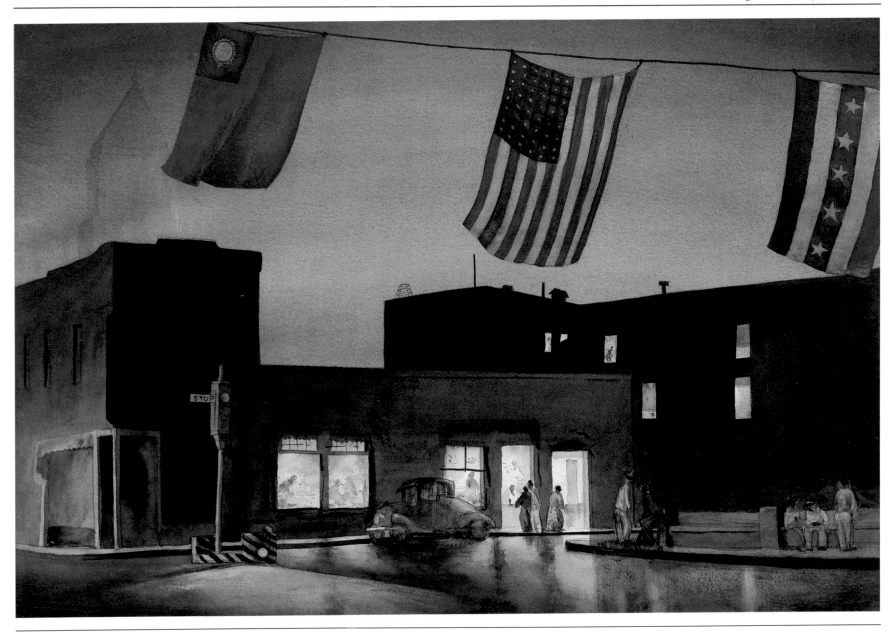

Thomas Theodore Craig studied at Pomona College in Claremont, California, and received his degree in botany in 1934. When he contracted tuberculosis in 1928, he was forced to move to the desert. He stayed in Cathedral City, California, until 1932. During this period he took up painting and drawing for the first time. After completing his studies at Pomona, he attended Chouinard Art Institute for a brief period and studied with F. Tolles Chamberlin, Clarence Hinkle, Millard Sheets, and Barse Miller, and with Andrew Dasburg in Taos, New Mexico.

In the 1930s Craig taught at Occidental College and the University of Southern California. Around 1934 he began to have frequent solo exhibitions in museums and galleries throughout California. He exhibited with the California Water Color Society and was included in the 1937 traveling exhibition, "The California Group." In 1941 he won a Guggenheim Fellowship which enabled him to travel throughout the Southwest painting mining towns. A year later, he was hired by *Life* magazine as a World War II artist-correspondent in Italy.

In 1950 Craig moved to Escondido, California, where he concentrated on the hybridization and cultivation of irises. Soon after, he stopped painting and devoted himself to botanical experimentation.

Craig received many awards for his paintings including a first prize, Oakland Art Gallery (1936); a purchase prize, California Water Color Society (1939); and a first prize, Artists of Los Angeles and Vicinity (1941).

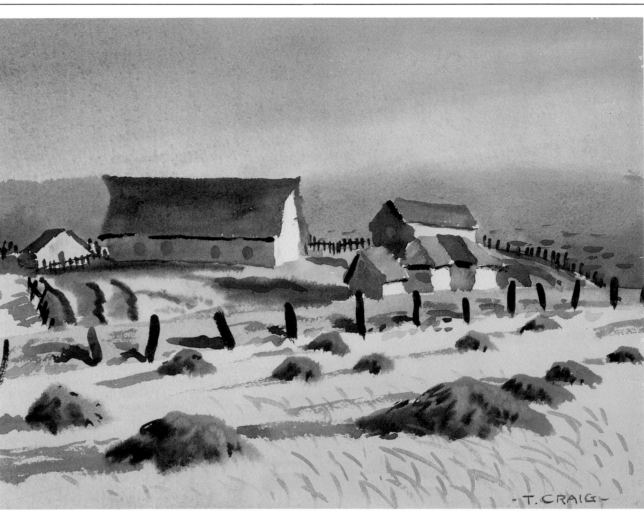

Plaza Los Angeles, 1935
Watercolor on paper
15 x 22½
Lent by the Los Angeles
County Fair Association

Shack, ca. 1936
Watercolor on paper
22 x 14
Lent by David and
Susan Stary-Sheets

California Oaks, ca. 1938
Watercolor on paper
15 x 22
Lent by David and
Susan Stary-Sheets

North Coast
Watercolor on paper
11⅜ x 15⅜
Lent by The Buck Collection
Laguna Niguel, California

WATSON CROSS, JR.

Born 18 October 1918
in Long Beach, California

After graduation from high school in Long Beach, Watson Cross, Jr. attended Chouinard Art Institute on a scholarship from 1938 to 1942. There he studied with Carl Beetz, Lawrence Murphy, Henry Lee McFee, Herb Jepson, and James Patrick, with whom he took watercolor classes for two years.

Cross has had a long and varied teaching career. After completing his studies, he taught out of his own studio for a couple of years before Mrs. Chouinard invited him to teach at the institute. He taught there from 1944 to 1969, when it became California Institute of the Arts. After Chouinard he taught at the Long Beach School of Art from 1971 to 1975, Art Center College of Design from 1976 to 1979, and California State University, Northridge from 1975 to 1981. Since then he has been teaching at Otis Art Institute of Parsons School of Design.

Cross became a member of the California Water Color Society in 1942, serving as president in 1953. During the 1940s he participated in regional exhibitions and annuals sponsored by museums in Los Angeles and San Francisco. In 1963 he was commissioned by the U.S. Air Force to document their Alaskan installations.

Cross has also worked on video performance pieces, and in 1985 received an honorable mention in Video U.S.A. at Eastern Tennessee State University.

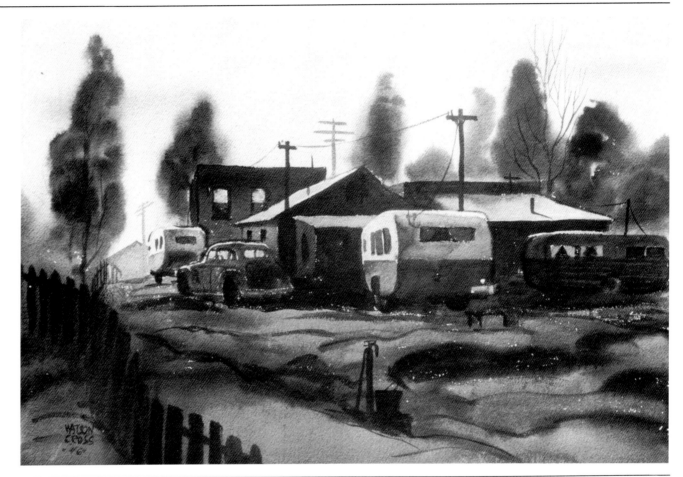

Trailer Camp, 1946
Watercolor on paper
15 x 22
Lent by Gordon and
Debi McClelland

PHIL DIKE

Born 6 April 1906
in Redlands, California

Phillip Latimer Dike grew up on a ranch in Southern California. After high school he moved to Los Angeles to attend the Chouinard Art Institute and studied with F. Tolles Chamberlin and Clarence Hinkle from 1924 to 1927 . In 1928 Dike went to New York to study drawing with George Bridgman at the Art Students League. He also took private lessons in painting from George Luks.

After returning to Los Angeles the following year, he taught life drawing and landscape painting at Chouinard and had a one-man show of his watercolors at the Los Angeles Museum of History, Science and Art. He then traveled to Europe, where he studied fresco technique at Fontainebleau, took up lithography, and in the spring of 1931, exhibited at the Paris Salon. When he returned to Southern California, he began teaching at Chouinard, where he remained until 1950.

In 1937 Dike's work traveled with "The California Group" exhibition. A year later he had his first one-man show at Ferargil Galleries in New York and was elected president of the California Water Color Society, in which he had been active since 1927. From 1935 to 1945 he was an instructor in drawing and composition at Walt Disney's training school and worked as color coordinator and story designer on several animated classics like *Snow White* and *Fantasia*.

In 1947 Dike opened the Brandt-Dike Summer School of Painting with Rex Brandt in Corona Del Mar. In 1950 when his friend Millard Sheets invited him to teach advanced painting at Scripps College and the Claremont Graduate School, Dike moved to Claremont, California. He taught there for twenty years, retiring in 1970.

Dike has received numerous awards and honors including two purchase prizes, California Water Color Society (1931 and 1946); first prize, San Francisco Golden Gate International Exposition (1940); and the Albert Dorne Purchase Award, American Watercolor Society (1960). In 1971 he was made a professor emeritus at Scripps College, and in 1953 he became a national academician. In 1977 the National Watercolor Society honored him on the golden anniversary of his membership.

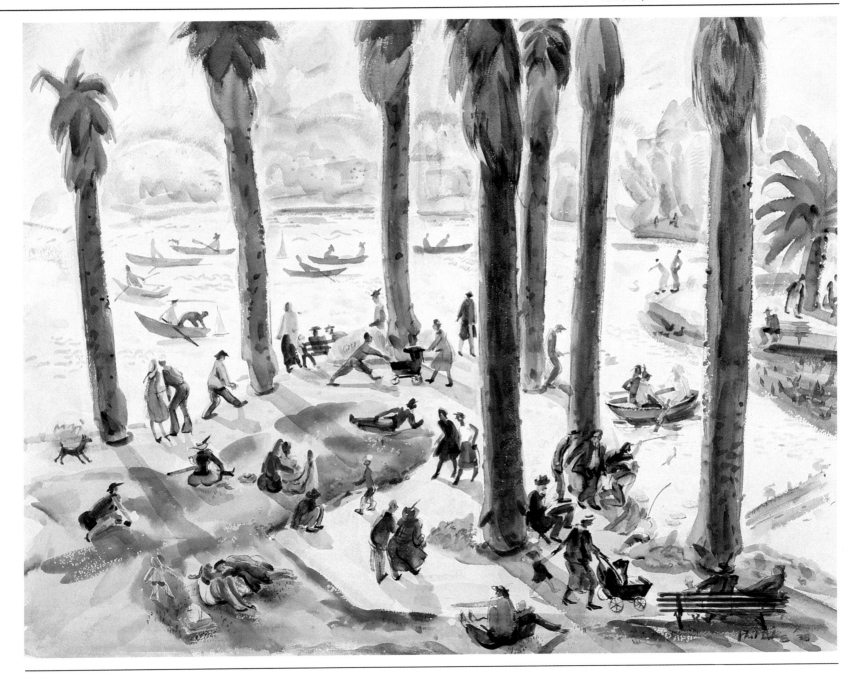

Morning, Inspiration Copper
1932
Watercolor on paper
15 x 22
Lent by The E. Gene Crain
Collection, Laguna Beach,
California

Clearwater Ranch, 1935
Watercolor on paper
14½ x 21½
Lent by Phil and Betty Dike

Echo Park or *California Sunshine*
1935
Watercolor on paper
18 x 24
Lent by Phil and Betty Dike

Fish Harbor or *Net Mending,
Newport,* 1935
Watercolor on paper
14 x 22
Collection of Mr. and Mrs.
Philip H. Greene

Then It Rained, 1939
Watercolor on paper
17½ x 26
Private Collection

Newport, ca. 1940
Watercolor on paper
15¼ x 22¼
Lent by The E. Gene Crain
Collection, Laguna Beach,
California

Grape Harvest, ca. 1941
Watercolor on paper
13¾ x 16
Lent by Princess Dike Goodwin

California Victorian
1942
Watercolor on paper
15 x 22
Lent by Phil and Betty Dike

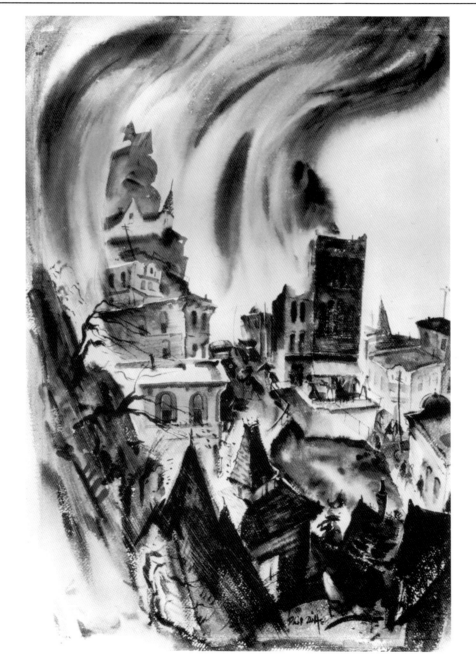

JAMES BUDD DIXON

Born 26 November 1908
in San Francisco, California
Died in 1967

James Budd Dixon attended the University of California, Berkeley, from 1920 to 1921 and from 1922 to 1923. He then attended the Mark Hopkins Institute of Art in San Francisco from 1923 to 1926 and in 1929. Years later, from 1946 to 1949, he took further instruction at the California School of Fine Arts.

Dixon was a member of the San Francisco Art Association, exhibiting regularly from 1936 to 1964. He had his first one-man exhibition at the San Francisco Museum of Art in 1939 and exhibited at the Golden Gate International Exposition the following year. Later Dixon was included in group exhibitions at the Denver Museum, the Museum of Modern Art in New York, the Cincinnati Museum, and The Oakland Museum.

Dixon taught at the California School of Fine Arts from 1947 to 1967. During those years, he created a body of abstract expressionist works for which he is now remembered. At that time his studio acted as a magnet, drawing to it a younger generation of artists.

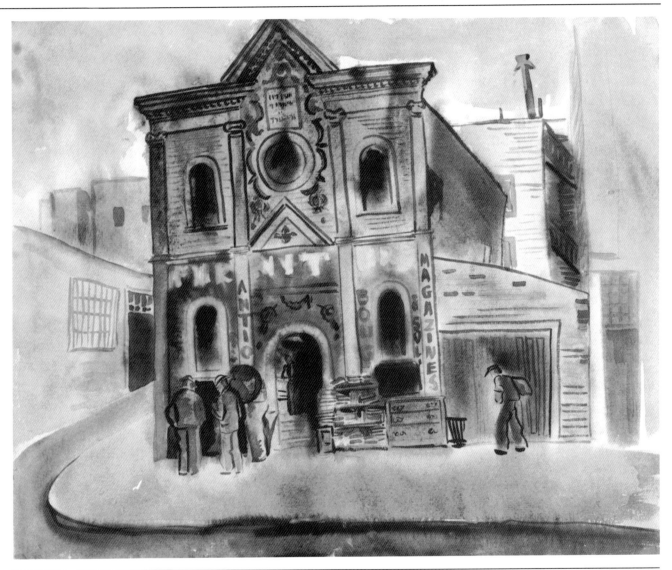

Untitled (Furniture Store)
Watercolor on paper
15 x 19
Lent by The Oakland Museum
Gift of Estate of Peggy Nelson Dixon

JAMES FITZGERALD

Born 8 March 1899
in Boston, Massachusetts
Died in 1971

James Fitzgerald was raised in Boston and served in the U.S. Marine Corps before beginning four years of study at the Massachusetts School of Art with Cyrus Dallin, Wilbur Hamilton and Ernest Major in 1919. In 1923 he studied at the School of the Museum of Fine Arts in Boston with Frederick Bosley, Phillip Hale and Leslie Thompson. From 1925 to 1928 he had studios in the area, and pursued gilding in order to learn a trade.

Fitzgerald moved to Monterey in 1928 and became associated with the Cannery Row circle that included John Steinbeck, Ed Rickettes, Robinson Jeffers, Edward Weston, Martha Graham and John Cage. During the next two years he produced a steady stream of watercolors and by 1930 was exhibiting with the California Water Color Society. In 1931 he became a member of the Carmel Art Association. From 1936 to 1938 he worked on projects for the WPA and the State Relief Administration. *Making the Coastal Highway* was created for the Customs House in Monterey, and *Cannery Row* for the city's North High School. He also worked on a mural with Bruce Ariss and Gus Gay for the county fairgrounds. In 1943 Fitzgerald moved to Monhegan Island off the coast of Maine, where he bought the studio and house formerly owned by Rockwell Kent.

Fitzgerald exhibited widely and received considerable attention after his one-man shows at the Stendahl Gallery in Los Angeles in 1940 and the Milch Galleries in New York in 1944. Although he continued to paint after he moved to the East, he rarely exhibited and spent a great deal of time traveling internationally. He died while visiting the coast of Ireland.

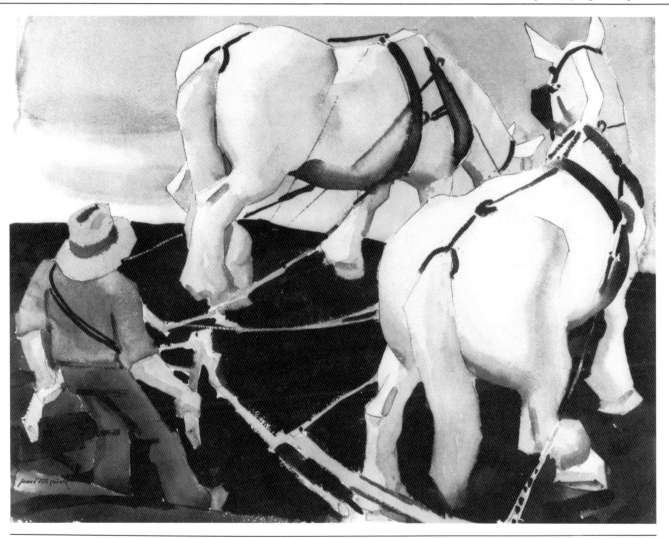

Quarrying, ca. 1936
Watercolor on paper
16¼ x 21¼
Lent by Robert and Nell Bonaparte

Carmel Valley Ranch
Watercolor on paper
30½ x 26
Private Collection

Spring Plowing
Watercolor on paper
18½ x 24½
Lent by Ed and Anne Hubert

BERNARD GARBUTT

Born 25 August 1900
in Ontario, California
Died in 1975

Brought up in a rural community, Charles Bernard Garbutt moved to Los Angeles when he was quite young. He began sketching farm and circus animals as a child and, although he had little formal art training, studied for a time at Chouinard Art Institute with Lawrence Murphy and Pruett Carter.

After graduating from high school, Garbutt was hired by the *Los Angeles Times* as a staff artist, designing covers and illustrating reports on farming events, county fairs, and horse shows for the Sunday supplement. When hard times hit at the beginning of the Depression, he was offered a job at Walt Disney Studios to do story-sketch and layout for *Snow White.* His real talents were soon discovered, and he was hired as an animator. He was also involved in the making of the film *Bambi.* Eventually he taught the analysis of animal action at Disney's training school, and beginning in the 1950s, taught anatomy and animal structure at Chouinard. During World War II, he worked at Screen Gems Productions.

Garbutt was not a member of any of the local art associations and rarely exhibited. Recognizing his artistic talent, Arthur Millier organized a one-man exhibit of his work at the Los Angeles Museum of Science, History and Art in the 1940s. It was not, however, until the 1970s that he became interested in exhibiting in galleries. In addition to his other interests, Garbutt wrote and illustrated many children's books, for which he won several national awards.

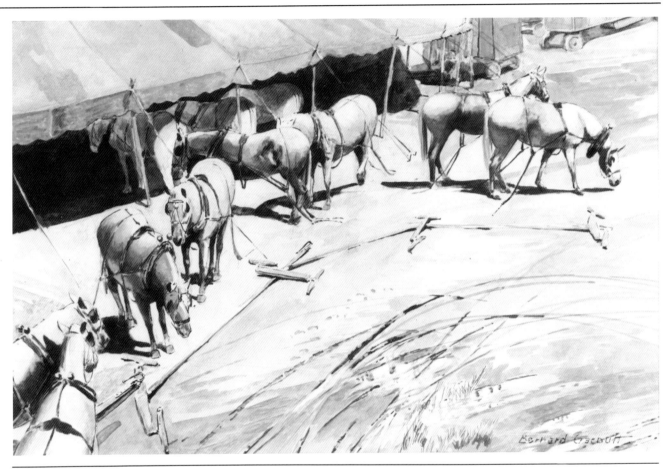

Circus Horses
Watercolor and gouache
on paper
11¼ x 17¼
Collection of Mrs. Bernard
Garbutt

HARDIE GRAMATKY

Born 12 April 1907
in Dallas, Texas
Died in 1979

Hardie Gramatky grew up in Southern California. He attended Stanford University from 1926 to 1928 and the Chouinard Art Institute from 1928 to 1930, where he studied with Clarence Hinkle, Pruett Carter and F. Tolles Chamberlin.

Gramatky began exhibiting regularly with the California Water Color Society in 1929. Although he painted in oil from time to time, his primary medium was watercolor. In the 1930s he worked for six years as one of Disney's favorite animators at Walt Disney Studios. He also illustrated for magazines such as *Fortune,* which hired him in 1937 to cover the Mississippi flood. Two years later his work traveled with "The California Group" exhibition, and he began to write and illustrate numerous children's books, including *Little Toot.* Although in 1936 he moved to the East where he became a freelance illustrator, Gramatky moved back to Hollywood during World War II to supervise training films for the U.S. Air Force. After the war he remained there for a while to work on the production of *G.I. Joe* before returning to New York. In 1947 he moved to Westport, Connecticut, where he spent the rest of his life.

Gramatky was elected a member of the National Academy of Design. Among the many awards and honors he received were the Osborn Prize, American Watercolor Society (1942); the Blair Prize, Chicago International Watercolor Show (1942); and the watercolor prize, Audubon Artists Exhibition, New York (1946).

Hollywood, 1944
Watercolor on paper
16 x 20
Lent by Gordon and
Debi McClelland

Hollywood Hills, 1945
Watercolor on paper
21½ x 28¼ (framed)
Lent by Mrs. Hardie Gramatky

Bridge Construction
Watercolor on paper
11 x 15
Lent by Gordon and
Debi McClelland

HAROLD GRETZNER

Born 3 December 1902
in Baltimore, Maryland
Died in 1977

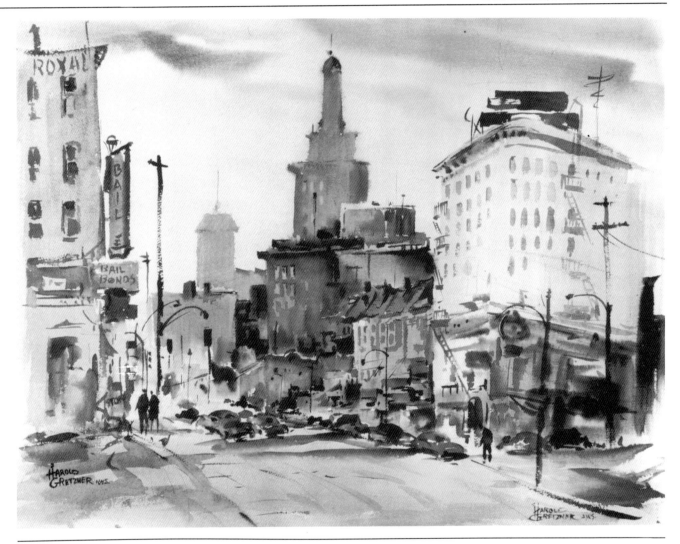

Harold Gretzner began his formal art training in Washington, DC. In the 1920s he moved to California and settled in the San Francisco Bay Area. There he completed his education at the College of Arts and Crafts in Oakland and then studied commercial lithography in San Francisco.

Gretzner worked primarily as a commercial artist in San Francisco, though he gave private lessons in watercolor to small groups. He was a member of the Thirteen Watercolorists and was actively involved in local and regional art associations, exhibiting principally in Northern California. His watercolors were essentially of Northern California subjects, painted on location in downtown Oakland, San Francisco, and along the coast of Monterey.

Over the years Gretzner won many awards for his watercolors in local and regional competitions. He was a member of the American Watercolor Society, the West Coast Watercolor Society, the Society of Western Artists, and the Oakland Art Association.

Downtown Oakland
Watercolor on paper
22 x 30
Lent by Gordon and
Debi McClelland

JOHN HALEY

Born 21 September 1905
in Minneapolis, Minnesota

John Charles Haley studied at the Minneapolis School of Art with Cameron Booth. He went to Europe, where he studied with Hans Hoffman in Munich and André Lhote in Paris. When he returned to the United States he taught in Minneapolis.

In 1930 he moved to the San Francisco Bay area where he began exhibiting and teaching art at the University of California, Berkeley. He was an important and influential figure there for forty-two years. He participated in the inaugural exhibition at the San Francisco Museum of Fine Art in 1935 and had a one-man show there in 1939. He was very active in the San Francisco Art Association from 1930 to 1960 and won several awards over the years. He became well-known for his watercolors and began exhibiting with the California Water Color Society in 1942.

Haley has always worked in other media as well. He has a fresco in the Government Island Administration building in Oakland and numerous stained glass windows in Midwestern churches. Since the 1950s he put more emphasis on his oil painting, working in an abstract expressionist style.

Richmond-San Rafael Ferries at Pt. Richmond, California
1939
Watercolor on paper
14½ x 20½
Lent by The Oakland Museum
Gift of the Art Guild of
The Oakland Museum Art Association

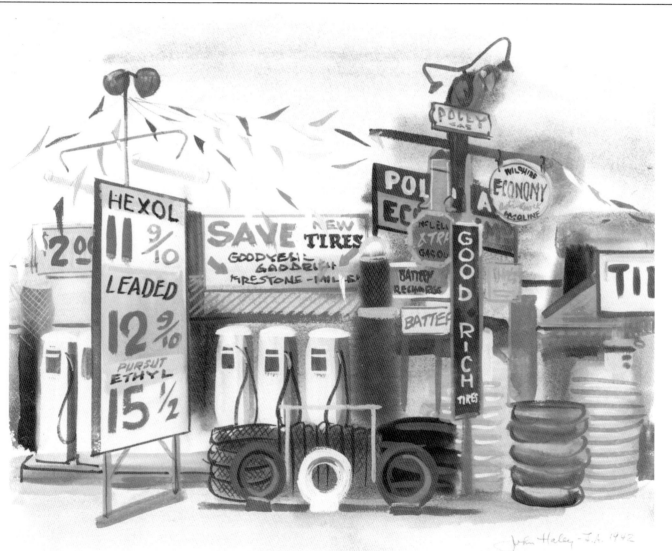

Prevent Fires or *Incinerators*
1941
Watercolor on paper
17 x 20
Lent by John and Nancy Weare

Gas, Eleven-Nine, 1942
Watercolor on paper
18 x 22
Lent by Gordon and Debi
McClelland

53

MABEL HUTCHINSON

Born 13 February 1903
near Shelley, Idaho

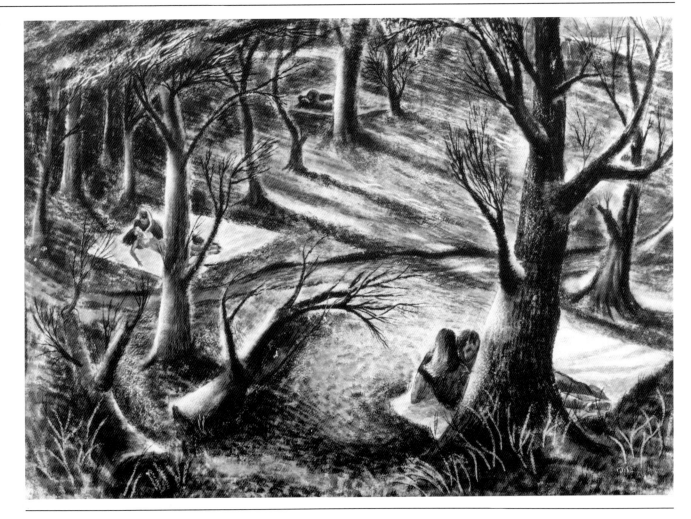

Mabel Christina Bennett Hutchinson was born in a two-room log cabin on a farm in Idaho. After completing high school in Blackfoot, Idaho, she took a year of art instruction at a college in Logan, Utah. In 1927 she married and left the farm to her two brothers. She and her husband set out for California in search of work, deciding to settle in Riverside, where they had friends.

Hutchinson worked on her own for a couple of years and then, in 1930, joined the Riverside Art Association, where she received the support of other artists. She enrolled at Riverside Junior College, graduating in 1937. The following year she joined a small group taking private lessons in landscape painting from Rex Brandt.

From 1939 to 1959 Hutchinson exhibited her watercolors regularly with the San Diego Fine Arts Gallery, the Laguna Beach Art Association, the Riverside Art Association, and the California Water Color Society. In 1959 she stopped painting and, like her husband, turned to working in wood. Using scraps of exotic wood, she began to create totems and decorative doors which were exhibited in 1968 at an international exhibition at the Museum of Contemporary Crafts.

Magic Carpet, 1941
Watercolor on paper
22 x 28
Lent by Jack Bennett

DONG KINGMAN

Born 11 April 1911
in Oakland, California

Dong Moy Chu Kingman moved with his family to Hong Kong when he was five years old because his father feared the imminent United States involvement in World War I. He studied at the Lingnan Branch School with the headmaster and teacher Szetu Wei learning Chinese calligraphy and watercolor painting as well as Western-style oil painting. Kingman moved with his family back to the San Francisco Bay area in 1929 and in 1931 he became part owner of a restaurant. With free time in the afternoons, he began to study oil painting at the Fox & Morgan Art School in Oakland but soon decided to become a watercolor painter.

Kingman began to paint street scenes, waterfronts, and skyscrapers. In 1936 he had a one-man show at the San Francisco Art Center that gave him overnight recognition. Assigned in 1935 to the watercolor division of the WPA, he spent five years on the project. Albert Bender began to buy his work and donate it to important museum collections. In 1941 Kingman won a Guggenheim Fellowship, which enabled him to travel and study throughout the United States for two years.

After the war Kingman moved to New York. He taught watercolor painting at Columbia University from 1946 to 1954 and between 1948 and 1953 at Hunter College, where he also taught the history of Chinese art. In 1954 he joined the faculty of the Famous Artists School in Westport, Connecticut.

Kingman has worked as an illustrator, a technical designer for motion picture studios, and on commission for hotels and banks, creating murals and mosaics. Among his awards are a first purchase prize, San Francisco Art Association (1936); a prize, Oakland Art Gallery

(1937); the Joseph Pennell Medal, Philadelphia Watercolor Club (1950); and a gold medal, National Academy of Design (1975), to which he had been elected in 1951.

California Hills, Monterey
1942
Watercolor on paper
21⅞ x 28
Lent by The San Diego
Museum of Art

San Francisco, 1944
Watercolor on paper
15⅜ x 20⅞ (framed)
Lent by The E. Gene Crain
Collection, Laguna Beach,
California

JOSEPH KNOWLES

Born 15 June 1907
in Kendall, Montana
Died in 1980

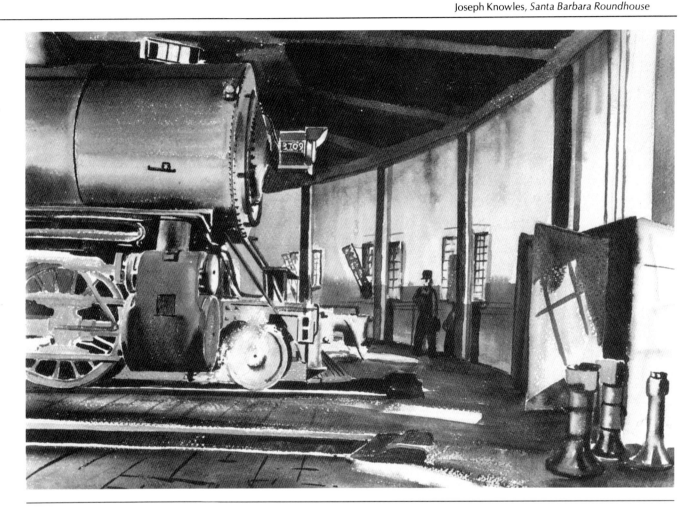

Joseph Edward Knowles, Sr. grew up in San Diego. He moved to Santa Barbara in 1927 to study at the Santa Barbara School of the Arts with Frank Morley Fletcher. In 1934 he went to Europe where he spent the year studying in Italy, France, and England. He received his M.F.A. at Claremont Graduate School in 1954.

Knowles began teaching after his return from Europe in 1935. Over the years he served as fine arts instructor at Cate School and Crane Country Day School, as instructor in art education for the University of California, Santa Barbara Extension, and as art education consultant for the Santa Barbara County Schools.

Knowles began to exhibit with the California Water Color Society in 1940. Most of his watercolors were of the California coastline painted on location. He exhibited widely at galleries and museums throughout California and had one-man shows at the San Diego Fine Arts Gallery, the de Young Museum, and the Santa Barbara Museum of Art, among others.

In addition to his work as a watercolorist, Knowles designed and executed mosaic murals and stained glass windows on private commission. In 1956 he worked on a large mural for Beckman Instruments, Inc. with Stan Backus.

Knowles was well-known in the arts community in Santa Barbara. He was a past president of the Santa Barbara Art Association, and in the 1960s participated in the organization of a new school of fine arts at Brooks Institute, where he served as co-director and president.

Santa Barbara Roundhouse
Watercolor on paper
15½ x 22¼
Santa Barbara Museum of Art
Gift of E. Vail Knowles Dinkins
and Joseph E. Knowles, Jr.

EMIL KOSA, JR.

Born 28 November 1903
in Paris, France
Died in 1968

Emil Jean Kosa, Jr. moved to the United States in 1907 when his father, who was also a painter and assisted Alphonse Mucha in Paris for twenty years, came here to work. Rather than pursue his education in the U.S., Emil Kosa, Jr. studied in Prague at the Academy of Fine Arts with Thille and at Charles University, from which he graduated in 1921. He returned to Los Angeles, where he studied at the California Art Institute in 1922. In 1927 he went to Paris and studied on scholarship at the Ecole des Beaux Arts under Franz Kupka and Paul Laurens.

In Los Angeles again in 1928, he met Millard Sheets and studied for a time at Chouinard Art Institute. In 1933 he began to work for Twentieth-Century Fox as a special effects artist. In 1939 he had his first significant one-man show at the Oakland Art Gallery. Thereafter, he had solo exhibits yearly throughout Southern California and occasionally in the East. In Los Angeles he showed primarily at Cowie Galleries. He taught at Otis Art Institute in 1939 and in 1947 at Chouinard Art Institute.

Emil Kosa, Jr. worked at Twentieth-Century Fox for thirty-five years. In his spare time he painted and helped to create the "California style" of watercolor painting. He was an active member of the California Water Color Society and served as president in 1945. Other honors and awards include a bronze medal, Panama Pacific Exposition, Long Beach (1928); the Zabriskie Purchase Prize, American Watercolor Society (1939); and the Ranger Purchase Award, National Academy of Design (1941). In 1964 he won an Oscar for his work on the movie *Cleopatra*. He was a member of the National Academy of Design.

Travelling Engine, 1936
Watercolor on paper
15 x 22
Lent by Elizabeth Kosa

Truckers' Gathering Spot
1938
Watercolor on paper
18 x 25
Lent by Gordon and Debi McClelland

Close to L.A. Gas Works
Watercolor on paper
19 x 25
Lent by Gordon and Debi McClelland

Hill Street–Los Angeles
Watercolor on paper
22 x 30
Lent by Elizabeth Kosa

Los Angeles City Street Scene
Watercolor on paper
22 x 30
Collection of Mr. and Mrs. Philip H. Greene

Near Playa Del Rey
Watercolor on paper
15 x 22
Lent by Elizabeth Kosa

Untitled (Hill Street Tunnel)
Watercolor on paper
22 x 30
Lent by The Fieldstone Company, Newport Beach, California

DAVID LEVINE

Born 13 December 1910
in Pasadena, California

David Phillip Levine was raised in the Los Angeles area and went to the University of Southern California, where he studied merchandising. Due to illness he was forced to leave the university and subsequently turned from the study of business to the study of art. From 1933 to 1936 he attended the Art Center School on scholarship studying with Stanley Reckless and Barse Miller, with whom he became good friends. He then spent a year in New York.

Upon his return he began to exhibit widely in Los Angeles. In 1936 he began showing with the California Water Color Society and received some local recognition in 1938 when he won the purchase prize for watercolor at the Los Angeles County Fair. In 1941 he had a one-man show at the Stendahl Galleries in Los Angeles, where he exhibited oils and etchings as well as watercolors.

Levine has exhibited in many local and regional exhibitions in California sponsored by institutions and organizations like the Foundation of Western Artists, the Los Angeles Museum of History, Science and Art, and the San Diego Museum of Art. Since 1940 he has participated in annuals sponsored by leading national art institutions like the Riverside Museum in New York, the Carnegie Institute, and the Denver Museum.

Burned Out, 1936
Watercolor on paper
14 x 21
Courtesy Tobey C. Moss Gallery,
Los Angeles, California

The Victim—Flood of '38
(Los Angeles River), 1938
Watercolor on paper
14½ x 21
Lent by the artist
Courtesy Tobey C. Moss Gallery,
Los Angeles, California

NAT LEVY

Born 21 October 1896
in San Francisco, California
Died in 1984

Nat Levy was a third-generation San Franciscan. He studied at the Mark Hopkins Art Institute and the California School of Fine Arts with Maynard Dixon, Armin Hansen, Maurice Logan, and Frank Van Sloun. He often accompanied Maynard Dixon on painting trips.

After graduating, he opened a studio as a freelance commercial artist. He eventually worked for the advertising agencies Foster and Kleiser and H. K. McKann as a graphic artist doing poster and billboard designs. Levy spent his free time painting views of San Francisco and often went north to the Mendocino coast. He taught watercolor painting in San Francisco at the University of California Extension and privately in outdoor classes.

Levy was one of the original Thirteen Watercolorists. He was president of the Society of Etchers, the Society of Western Artists (three times), and the West Coast Watercolor Society (twice). He was one of only twenty-five American painters chosen to exhibit at the Royal Gallery in London in 1977 and received numerous awards for his work.

Monday Breeze
ca. 1940
Watercolor on paper
22 x 30
Lent by Gordon and
Debi McClelland

Sunday on the Farm
ca. 1940
Watercolor on paper
20 x 27
Lent by Gordon and
Debi McClelland

ARTHUR LONERGAN

Born 1906
in New York City, New York

Arthur Lonergan grew up on the East Coast and studied at the Columbia University School of Architecture. In the late 1920s he took further instruction at the Ecole des Beaux Arts in Paris.

On his return to the United States, Lonergan traveled across the country, visiting Mexico, before settling in the Los Angeles area in 1935. Many of the watercolors done on his journeys include buildings he reproduced with great accuracy.

Lonergan worked for many years as an art director for Paramount, Universal, and MGM Studios. He also worked as a freelance technical illustrator, producing architectural renderings. He exhibited with the California Water Color Society for a short time in the early 1950s.

Backyard Chatter
ca. 1940
Watercolor on paper
15 x 18
Private Collection

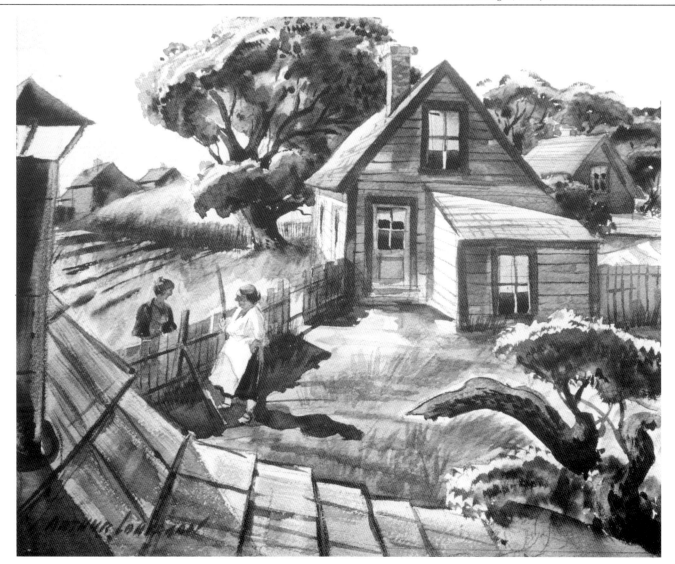

ERLE LORAN

Born 3 October 1905
in Minneapolis, Minnesota

Erle Loran attended the University of Minnesota and then studied at the Minneapolis School of Art under Cameron Booth. After completing his studies in 1926, he received the Chaloner Foundation Prize, a travel scholarship that enabled him to reside in Europe for four years.

After returning to the United States, Loran exhibited his work widely; in 1933 it was included in an exhibition at the Museum of Modern Art in New York. He moved to the San Francisco Bay Area in 1936, where he began a distinguished teaching career as professor of art at the University of California, Berkeley. His participation in the local scene began immediately; in 1936 Loran had a one-man show at the San Francisco Museum of Art. That same year he exhibited his work at the Oakland Art Gallery and the San Francisco Art Association. He began exhibiting regularly with the California Water Color Society in 1940.

In addition to his achievements as a painter and teacher, Loran is also a critic, well-known for his contributions to national magazines and as author of the book, *Cezanne's Composition.* He also has a notable collection of African and Pre-Columbian art, which he began to acquire in 1926.

Loran had further instruction with Hans Hoffman while in New York City in 1960. He is a professor emeritus of the University of California, Berkeley.

Waterfront-Oakland
1936
Watercolor on paper
16 x 20
Private Collection

DAN LUTZ

Born 7 July 1906
in Decatur, Illinois
Died in 1978

Dan Lutz studied at James Milliken University for a year and then transferred to the Art Institute of Chicago, where he studied from 1928 to 1931 with John Norton and Boris Anisfeld. There in 1928 Lutz began to paint in watercolor.

In 1931 Lutz was awarded the James Nelson Raymond European Traveling Fellowship by the Chicago Art Institute, which sent him to Europe for a year of travel and study. Upon his return he moved to Los Angeles and took a position as a member of the fine arts faculty at the University of Southern California. He taught there until 1942, serving as head of the painting department beginning in 1938. He completed his education while teaching, and received his B.F.A. in 1933 from the same institution. He taught at the Chouinard Art Institute from 1944 to 1952 and in summer sessions at the Chicago Art Institute and the Summer School of Painting in Saugatuck, Michigan. After 1936 he exhibited regularly with the California Water Color Society. Four years later, he began an exhibition schedule of yearly one-man shows with Dalzell Hatfield Galleries in Los Angeles, interrupted only by exhibitions in major Southern California museums.

In the early 1940s, inspired by Negro spirituals, Lutz began a series of expressionistic paintings in oil, which received notable distinction. In the 1950s and 1960s he continued to paint regularly, lectured occasionally, and traveled to Mexico, Europe, and New Zealand for extended periods of time.

Among the many awards that Lutz received for his paintings are the Thomas B. Clark Prize, National Academy of Design (1941); a purchase prize, First National Exhibition, Corpus Christi,

Texas (1945); the Wheelwright Prize, National Watercolor Exhibition, Pennsylvania Academy (1945); and five prizes from the California Water Color Society (1936, 1938, 1942, 1945 and 1952).

End of the Line, 1937
Watercolor on paper
14 x 20
Lent by Arlington Gallery, Santa Barbara, California

Steam Shovel, 1937
Watercolor on paper
13⅝ x 20¼
Lent by Mr. and Mrs. Peter Fleurat

Two Engines, 1937
Watercolor on paper
12¼ x 18¾
Lent by Mr. and Mrs. Peter Fleurat

Easter Sunday or *After the Wedding*
1939
Watercolor on paper
20¾ x 28
Lent by Mr. and Mrs. Peter Fleurat

Freight Siding, 1939
Watercolor on paper
13½ x 21¾
Lent by Arlington Gallery, Santa Barbara, California

Rehearsal II, 1942
Watercolor on paper
21⅞ x 28⅛
Lent by The San Diego Museum of Art

Cracking Plant
Watercolor on paper
13½ x 19⅞
Lent by Mr. and Mrs. Peter Fleurat

FLETCHER MARTIN

Born 29 April 1904
in Palisade, Colorado
Died in 1979

Fletcher Martin, *Blue Sea Fillet Co.*, ca. 1939

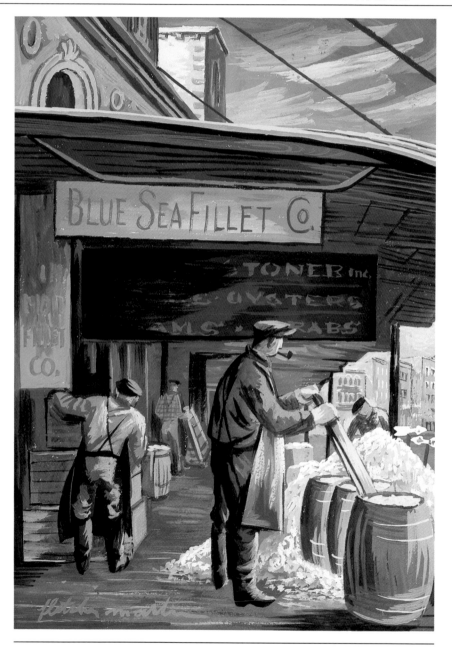

Fletcher Martin spent his youth moving around the Western frontier with his family. His father, an itinerant newspaper man, bought up the failing local newspapers wherever they went. Fletcher finally left home and spent the next few years drifting. After working as a lumberjack, mule team driver, and boxer, he joined the U.S. Navy. In 1926 he was discharged in San Francisco.

Martin soon moved to Hollywood, where he worked as a printer for nine years. At this time he began his self-taught education as an artist. In 1931 he won a competition to attend the Stickney School of Art but had to turn the award down. He became deeply impressed with David Alfaro Siqueiros when he met him in 1932 and assisted him on a private commission in 1933 for a movie director living in Malibu.

In 1934 Martin had his first one-man show at the San Diego Fine Arts Gallery, followed by another at the Los Angeles Museum in 1935. Martin won both the first Los Angeles Museum Award and the van Rensselaer Wilbur Prize at the annual Painters and Sculptors Exhibition at the Los Angeles Museum that year. In 1936 he had one-man shows at Howard Putzel Gallery in Hollywood and at Jake Zeitlin Gallery in Los Angeles.

Martin participated in the Federal Arts Project in 1936. He created a mural for North Hollywood High School and became nationally known as a result. Further commissions followed for the Federal Building in San Pedro, California, the Boundary County Courthouse in Bonners Ferry, Idaho, the post office in La Mesa, Texas, and the post office in Kellogg, Idaho. During this period he also taught drawing at the Art Center School in Los Angeles. When Martin's watercolors were shown at

the Riverside Museum in 1939 with the California Water Color Society, he received further recognition.

In 1940 Martin had a one-man exhibition at the Midtown Galleries in New York and was invited to replace Grant Wood as professor of fine arts at the University of Iowa. He replaced Thomas Hart Benton at the Kansas City Art Institute the following year. In 1943 he left Kansas City to cover the North Africa theater and the Normandy campaign for *Life* magazine as an artist-correspondent.

Martin settled in New York City in 1945, working on documentary projects for the next two years. From 1947 to 1949 he taught at the Art Students League, then moved to the University of Florida, where he held the position of visiting artist for two years.

Until his death, Martin was constantly sought out as a teacher, continued to exhibit his work, and received considerable recognition.

Blue Sea Fillet Co.
ca. 1939
Gouache on paper
14 x 10
Collection of Jason Schoen,
Houston, Texas

BEN MESSICK

Born 9 January 1901
in Strafford, Missouri
Died in 1981

Benjamin Newton Messick was raised in the Missouri Ozarks and spent his early childhood observing the townsfolk who frequented his father's country store. With the outbreak of World War I, he joined the forces and served in France.

After the war Messick settled in Los Angeles, and from 1923 to 1932 attended the Los Angeles School of Art and Design and Chouinard Art Institute. He studied with F. Tolles Chamberlin, Pruett Carter, and Clarence Hinkle. In 1927, while still a student at Chouinard, he won second prize at the Pennsylvania Academy of Fine Arts for a watercolor.

From 1931 to 1944, Messick worked as a freelance commercial artist and fashion illustrator, and served as an artist on the Federal Arts Project. From 1934 to 1941 he worked on murals in Los Angeles for the Frank Wiggins Trade School, the California State Building, and the Hall of Records.

Messick taught life drawing at Chouinard Art Institute from 1943 to 1951 and then made a two-year tour of the West and Midwest painting and sketching. He also taught at the San Diego School of Arts and Crafts and the Messick-Hay Studio with his wife, Velma Hay.

Throughout the 1930s and 1940s, Messick exhibited his lithographs and paintings in numerous one-man exhibitions, including the San Francisco Museum of Art, the Springfield Museum of Art, Missouri, the Santa Barbara Museum of Art, and the National Gallery in Washington, DC.

In 1948 the city of Strafford, Missouri, made him guest of honor during the Strafford Annual Carnival. In 1956 he was elected a fellow of the Royal Society of Arts and in 1969 was awarded the Diplome d'Honneur from the

International Art Guild, Monte Carlo, Monaco.

A Corner in Old Chinatown
ca. 1939
Watercolor on paper
11 x 15
Lent by The Eclectic Gallery

Summer Camp by the Sea
ca. 1939
Watercolor on paper
14 x 10
Lent by Peter and Gail Ochs

Waiting for the Spec
ca. 1939
Watercolor on paper
11 x 15½
Lent by The Eclectic Gallery

Circus Barker
Watercolor on paper
14 x 16
Lent by Gordon and Debi McClelland

BARSE MILLER

Born 24 January 1904
in New York City, New York
Died in 1973

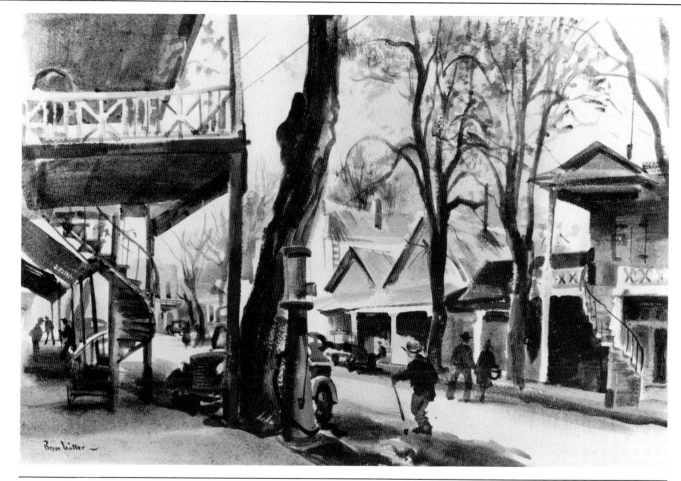

Barse Miller attended the National Academy of Design in New York and the Pennsylvania Academy of Fine Arts. He studied with Henry B. Snell, Henry Breckenridge, and Arthur B. Carles. While studying at the Pennsylvania Academy of Fine Arts he was awarded two Cresson Traveling Scholarships, enabling him to study in Paris. He began to work in the watercolor medium in 1922.

Miller moved to California in 1924, where he lived until World War II. From 1927 to 1929, he taught drawing and painting at Chouinard Art Institute. In 1928 he had his first one-man show at the Los Angeles Museum of History, Science and Art, followed by others there in 1930 and 1936. In 1930, strongly influenced by José Clemente Orozco who was working on a fresco in Claremont, Miller executed his own fresco mural in Sommer and Kaufmann's Modern Store in San Francisco. The following year he designed another mural for the lobby of the Southern California Edison Building in Los Angeles. In 1932 he began teaching at the Art Center School, where he remained until 1942.

Miller's New York dealer was Ferargil Gallery. He had one-man shows there for ten years beginning in 1936. Later, he moved to Cowie Galleries in Los Angeles, where he had one-man shows from 1946 to 1967.

Miller executed WPA mural commissions for the post offices in Goose Creek, Texas, and Claremont, California. In 1933 he won a national competition to complete a mural for the post office in Island Pond, Vermont.

In 1941 Miller acted as a special correspondent for *Life* magazine, documenting the training of troops at Fort Ord, California. During the war, he served overseas from 1943 to 1946 as chief of the Combat Art Section, General MacArthur's Pacific headquarters.

After his discharge, Miller received a Guggenheim Fellowship and went to live in New York. He taught at the Art Students League for a short period and then became assistant professor and chairman of the Art Department at Queens College. He formed a summer school in Maine called the Rangemark Master Class in Watercolor.

Miller received many honors and awards for his work including an honorable mention, Pennsylvania Academy of Fine Arts (1936); the gold prize, Los Angeles Museum of History, Science and Art (1929); and a purchase prize, California Water Color Society (1935). He was a member of the National Academy of Design.

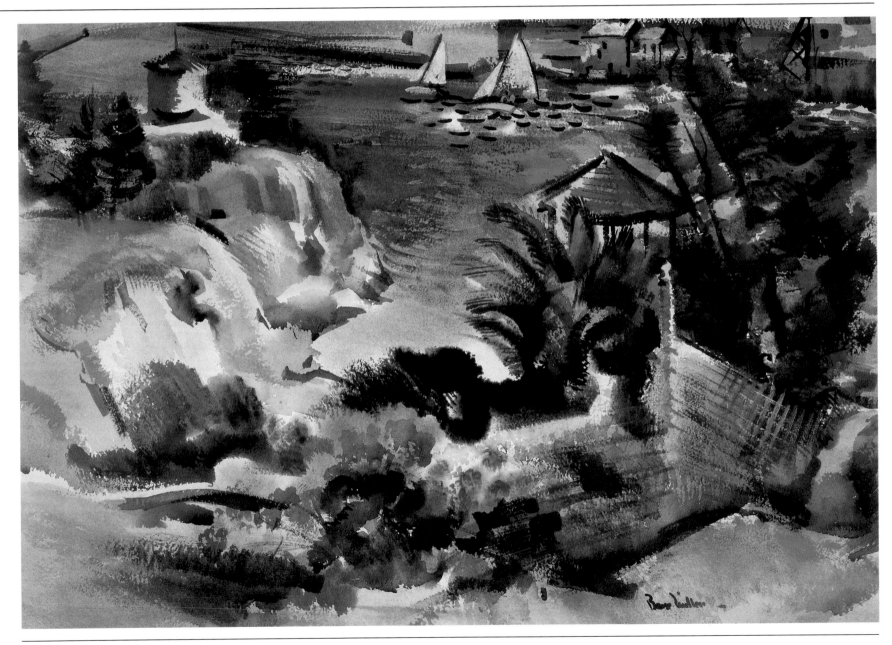

Stockton Street, 1935
Watercolor on paper
21¾ x 29¼
Lent by Los Angeles County
Museum of Art, California
Water Color Society Collection
of Watercolor Paintings
Purchase Award, 1935

Walnut Tree, 1938
Watercolor on paper
21½ x 25½
Lent by The E. Gene Crain
Collection, Laguna Beach,
California

Balboa Inlet, 1942
Watercolor on paper
18½ x 28
Collection of Mr. and Mrs.
Philip H. Greene

Auburn, California
ca. 1945
Watercolor on paper
15⅝ x 22⅝
Lent by D. Wigmore Fine Art, Inc.

Orange County Idyll
Watercolor on paper
13⅝ x 21⅞
Lent by D. Wigmore Fine Art, Inc.

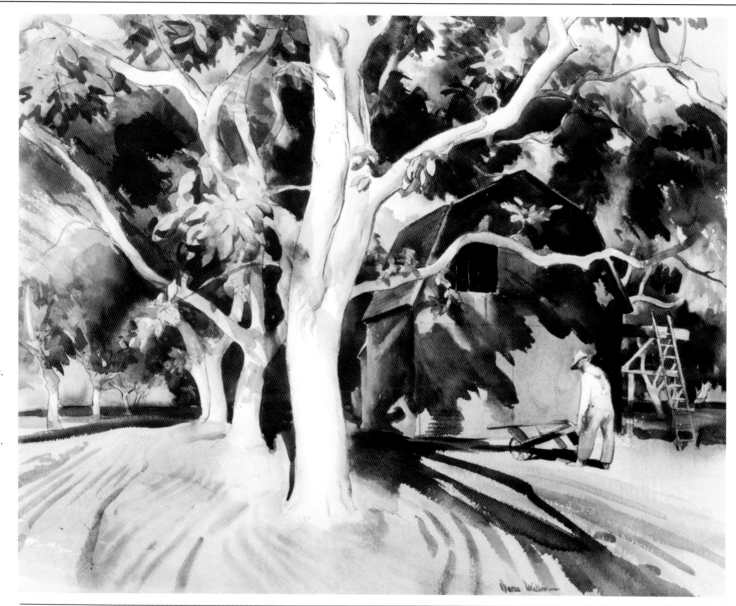

ARTHUR MILLIER

Born 19 October 1893
in Somersetshire, England
Died in 1975

Arthur Henry Thomas Millier went to school in England before settling in Los Angeles in 1908. He graduated from Los Angeles High School in 1911. For about three years he worked as a commercial artist before serving with the First Canadian Pioneers in World War I until 1919. After returning to the United States, Millier studied at the California School of Fine Arts and at the Los Angeles Art Students League under Rex Slinkard and Stanton MacDonald-Wright. Most interested in the etching and watercolor media, he exhibited at Cannell and Chaffin Galleries in 1923 and at Jake Zeitlin's Gallery in 1928.

From 1926 to 1958, Millier served as art critic of the *Los Angeles Times*. He stopped etching and painting around 1937, due to the pressure of his duties. In 1954 he received the Frank Jewett Mather Award for the best newspaper art criticism in cities of over 500,000 in the United States and Canada.

Upon his retirement in 1959 Millier moved to San Luis Obispo and resumed his activity as an artist. He was honored with a retrospective of his work at the Los Angeles Municipal Art Gallery in 1972 before he moved to the East.

Millier served the Southern California artistic community for over thirty-two years by bringing national attention to the work of its artists and by teaching and lecturing at various institutions. In addition to the *Los Angeles Times*, Millier wrote for *California Arts and Architecture* from 1921 to 1926, *Time* magazine as an art and music correspondent from 1930 to 1931, *Art Digest* from 1934 to 1948, and the *Christian Science Monitor* from 1930 to 1940.

He taught etching in his own studio from 1924 to 1926, at Chouinard Art Institute from 1928 to 1929, and at Pasadena Art Institute from 1929 to 1931. He lectured in art history and aesthetics at Otis Art Institute from 1939 to 1945 and in art history at the University of Southern California.

Millier exhibited with the California Water Color Society in 1933 and was later an honorary member of the society.

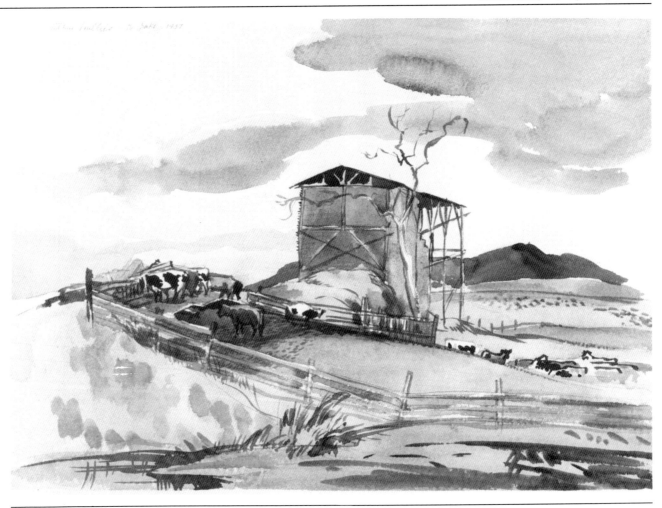

The Hay Stack, 1937
Watercolor on paper
11 x 15
Lent by Mrs. Jake Zeitlin

ALEXANDER NEPOTE

Born 6 November 1913
in Valley Home, California
Died in 1986

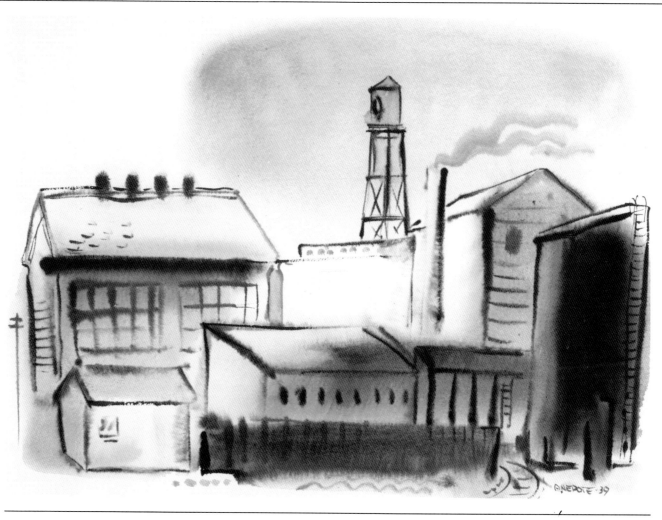

Alexander Nepote was raised on a ranch near Stockton, in California's central valley. He graduated from high school in Santa Rosa and then moved to Oakland, where he studied on scholarship at the California College of Arts and Crafts, receiving a degree in art education in 1939. He continued his education at the University of California, Mills College Graduate Division, receiving an M.A. in 1942.

While still in college, he began to exhibit his watercolors and in 1939 joined the California Water Color Society. The same year he exhibited at the Golden Gate International Exposition and the San Francisco Museum of Art. In 1944 he began to participate in exhibitions sponsored by leading national art institutions like the Riverside Museum in New York. From 1945 to 1950 he taught and served as the dean of faculty at the California College of Arts and Crafts, and from 1959 to 1977 he was professor of art at San Francisco State College.

Nepote won numerous awards for his work, including the Phelan Award, San Francisco (1941); a purchase prize, Oakland Art Gallery (1955); a purchase prize, California Water Color Society (1955); a prize, Denver Art Museum (1960); and prizes from the National Watercolor Society (1978 and 1979). In 1977 he was made professor emeritus at San Francisco State College.

Factory in Oakland, 1939
Watercolor on paper
15¼ x 23
Lent by John and Nancy Weare

PHIL PARADISE

Born 26 August 1905
in Ontario, Oregon

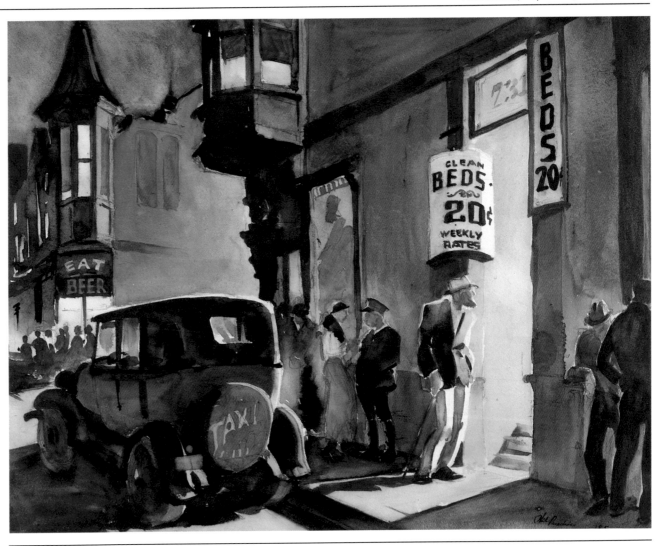

Phillip Herschel Paradise grew up in Bakersfield, California. He studied at the Santa Barbara School of Art with Frank Morley Fletcher and at Chouinard Art Institute with F. Tolles Chamberlin and Pruett Carter from 1927 to 1931. He worked his way through school as a sign painter, supporting his father who lived in Santa Barbara. Later he studied with Leon Kroll, Rico Lebrun, and David Alfaro Siqueiros.

In the late 1920s, while at Chouinard, Paradise began to concentrate on the regional scenes of the Los Angeles area which brought him much critical acclaim. During this period he began exhibiting with the California Water Color Society, later serving as president in 1939. In 1929 he exhibited a painting in a national exhibition at the Pennsylvania Academy.

After graduation from Chouinard, Paradise began teaching at the school and served as director of fine arts from 1936 to 1940. Subsequently, he worked at Paramount Studios as art director and production designer for Sol Lesser Productions until 1948 and as a commercial artist for the magazines *Fortune, Westways,* and *True* from 1940 to 1960. At the same time he actively exhibited his watercolors in galleries in Los Angeles and New York. In the mid 1940s his paintings became more stylized and reflected his interest in the foreign lands he visited—Central America, Mexico and the Caribbean.

Paradise has been a visiting lecturer at the University of Texas, El Paso, and at Scripps College, substituting for Millard Sheets. Paradise set up a successful print workshop in the 1940s in Cambria, California, and later directed Cambria Summer School and Greystone Galleries.

Among the many awards Paradise has received for his work are a second prize, Oakland Art Gallery (1938); first prize, Los Angeles County Fair (1939); a prize, Golden Gate Exposition (1939); a purchase award, Philadelphia Watercolor Club (1941); the Dana Medal, Philadelphia Watercolor Award (1943); and a purchase award, San Francisco International Exhibition (1941). He became an associate member of the National Academy of Design in 1953.

Hauling in the Nets, ca. 1931
Watercolor on paper
13½ x 20¾
Lent by Mike and Susan Verbal

*Oil Field on the Mesa,
Santa Barbara,* 1931
Watercolor on paper
15 x 21¼ (framed)
Lent by The E. Gene Crain
Collection, Laguna Beach,
California

Corral, ca. 1935
Watercolor on paper
15 x 22⅝ (framed)
Lent by The E. Gene Crain
Collection, Laguna Beach,
California

Flop House, Taxi, Whore
Watercolor on paper
14½ x 18
Collection of James and
Linda Ries

Nevada City of California
Watercolor on paper
16½ x 21½
Lent by George Stern,
Fine Arts, Encino, California

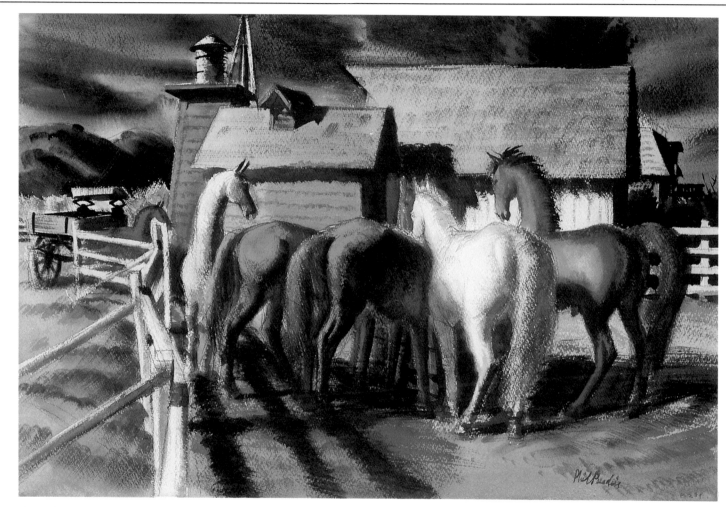

JAMES PATRICK

Born 14 September 1911
in Cranbrook, B.C., Canada
Died in 1944

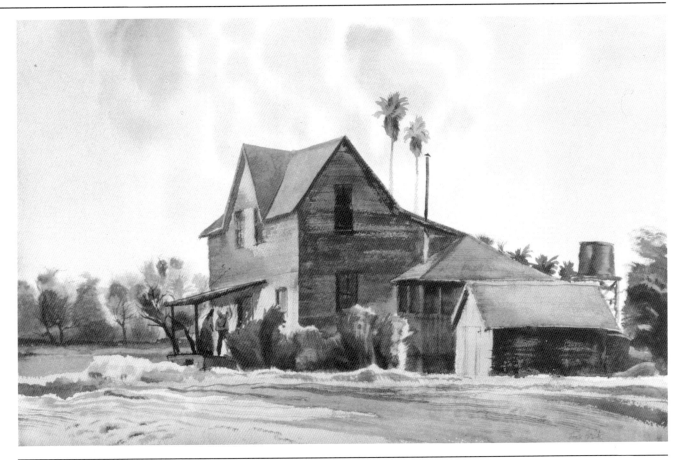

James H. Patrick came to California with his family as an infant. When he was about thirteen years old, they moved to Los Angeles County. He attended high school in Hollywood and then accepted a three-year scholarship to Chouinard Art Institute.

When Patrick was twenty years old he taught figure drawing and landscape painting at Chouinard, staying for three years. In 1935 he became a member of the California Water Color Society. Jake Zeitlin gave him a one-man show of watercolors he had made of Big Sur, on the Monterey coast, in 1937. A year later, he was back at Chouinard, where he taught until about 1942. During this period, he assisted Millard Sheets on several mural commissions, including the State Mutual Savings and Loan Building, Los Angeles, the J. W. Robinson, Co., Los Angeles, and the South Pasadena Junior High School auditorium. Patrick also worked as a pre-production artist for Columbia, Universal, and United Artists Pictures Corporations.

In 1942 the Los Angeles Museum of History, Science and Art had a one-man show of his oils and watercolors. Two years later, at the age of thirty-three, he died of pulmonary tuberculosis.

Industrial
Watercolor on paper
15½ x 22⅞
Lent by Ted Mills Fine Art

Untitled
Watercolor on paper
15¼ x 22½
Lent by Ted Mills

CHARLES PAYZANT

Born 18 February 1898
in Halifax, Nova Scotia, Canada
Died in 1980

Charles Payzant was raised in Nova Scotia and served in World War I. He was educated in Canada and England before settling in Los Angeles in the 1920s. He studied at Otis Art Institute and Chouinard Art Institute.

Payzant exhibited sporadically with the California Water Color Society beginning in 1930. In 1931 he was awarded first prize for painting in the annual exhibition at the Los Angeles Museum of History, Science and Art. Throughout the 1930s and 1940s, Payzant worked as a freelance commercial artist and for twelve years as a background artist at Walt Disney Studios. He continued to produce many fine watercolors and to illustrate children's books, which were written by his wife under the name of Terry Shannon-Payzant.

Payzant worked for the MacMillan Publishing Company as art director on the *Dick and Jane* series of grade school readers. In addition, he produced several murals on private commission.

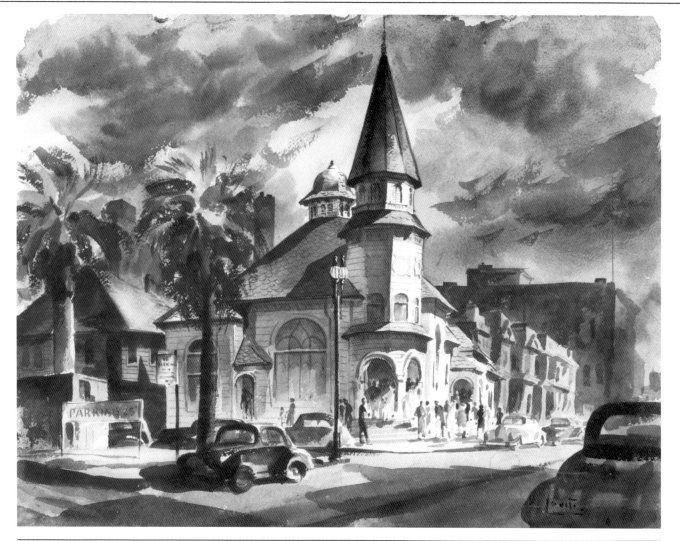

Wilshire Blvd., 1931
Watercolor on paper
19½ x 24
Lent by Gordon and
Debi McClelland

The Club Women, ca. 1939
Watercolor on paper
18 x 15
Lent by Terry Shannon-Payzant

Stormy Sunday, ca. 1939
Watercolor on paper
17 x 22
Lent by Terry Shannon-Payzant

Conversation
Watercolor on paper
11¼ x 15⅜
Lent by Martin Isaacson

Hay Wagon
Watercolor on paper
15 x 22
Lent by Terry Shannon-Payzant

FRED PENNEY

Born 10 January 1900
in Fullerton, Nebraska
Died in 1988

Fred Penney, *Mexican Madonnas* or *Madonna of Chavez Ravine*, ca. 1932

Frederick Doyle Penney studied briefly at the University of Nebraska, the Art Institute of Chicago, and the Art Students League in New York. However, his primary art education was at Chouinard Art Institute—in fact, he came from the East in 1924 specifically to study there with F. Tolles Chamberlin, Clarence Hinkle, and Pruett Carter.

He started exhibiting with the California Water Color Society in 1930. Throughout much of the 1930s he was an exhibiting artist, while also operating a design company in Los Angeles. With his wife, Janice, he designed lamps, painted screens, and completed murals for homes and small businesses. They also worked on children's books, with Penney doing the illustrations. In 1939 he participated in the Golden Gate International Exposition and in 1942 in the Society for Sanity in Art Exhibition.

That same year Penney moved to Libertyville, Illinois, to work in his father's factory in Chicago. He continued to paint, adapting to the different light and coloration. In 1957 he returned to California and settled in the desert area near Palm Springs, where he devoted himself to capturing the desert light and atmosphere in oil paintings until his death.

Mexican Madonnas or *Madonna of Chavez Ravine*, ca. 1932
Watercolor on paper
16 x 20
Lent by Edmund and Mercedes Penney

ELMER PLUMMER

Born 6 November 1910
in Redlands, California
Died in 1987

Elmer Plummer attended Chouinard Art Institute, studying with Lawrence Murphy, Millard Sheets, Pruett Carter, and Clarence Hinkle. He was one of several students who assisted David Alfaro Siqueiros in the completion of a mural in the courtyard of the institute in 1932.

After completing his studies in 1934, Plummer worked for a time as an artist at Warner Bros. Studios and then moved to Walt Disney Studios, where he remained for many years, working on early animated classics like *Fantasia* and *Dumbo*.

Plummer was an active member of the California Water Color Society from 1933 to 1942. During this period he exhibited locally and won awards from the Los Angeles Art Association, the Golden Gate International Exposition, and the Pennsylvania Academy of Fine Arts. He was also commissioned to complete murals for the YMCA in Pasadena, California.

Later, Plummer taught classes at Chouinard Art Institute and life drawing in the advanced animation classes at the California Institute of the Arts.

The Dead Palm, 1935
Watercolor on paper
15 x 20
Lent by Gordon and
Debi McClelland

Bells of the Nineties
Watercolor on paper
13½ x 21½
Lent by Raymond Cuevas

Early Morning Traffic
Watercolor on paper
14 x 18
Lent by Gordon and Debi
McClelland

JULIE POLOUSKY

Born 4 April 1908
in Philadelphia, Pennsylvania
Died in 1976

Julie Raymond Polousky was raised in the East. In the early 1930s she studied at the Art Students League in New York. By 1935 she was living in Southern California and exhibiting with the Long Beach Art Association. She studied further with Vanessa Helder, Sam Hyde Harris, and Loren Barton.

With her husband in the U.S. Marines, Polousky lived in a number of different locations throughout the 1930s and 1940s. Living in Hawaii during the attack on Pearl Harbor, she painted a series of watercolors in response to her experience.

After the war, she lived in Vallejo and Long Beach. She exhibited regularly with the Long Beach Art Association, the Laguna Beach Art Association, the California Water Color Society, and the Women Painters of the West, frequently receiving awards.

Loading Ship, 1942
Watercolor on paper
19 x 25
Lent by Jay T. Last

The Woven Fence
ca. 1944
Watercolor on paper
15 x 22
Lent by Gordon and
Debi McClelland

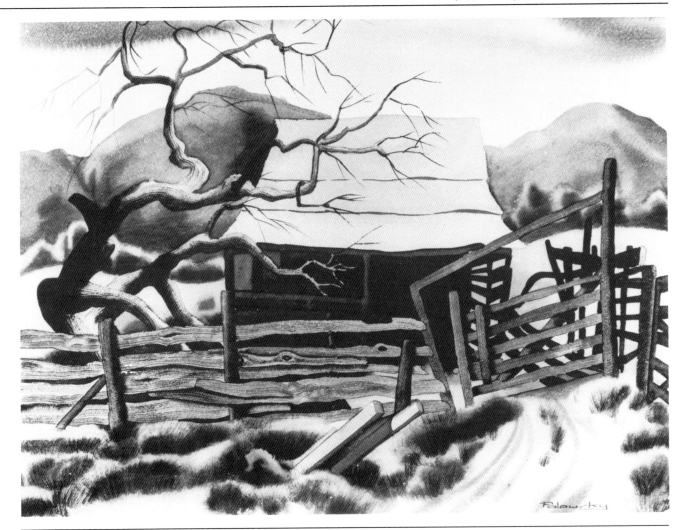

GEORGE POST

Born 29 September 1906
in Oakland, California

George Booth Post moved to San Francisco in 1919. After high school, he attended the California School of Fine Arts on a scholarship for two years. There he experimented with various media including watercolor. After completing his studies in 1927 he worked in the fields of printing and advertising and continued to explore watercolor painting.

In 1932 Post had a one-man exhibition at the Art Center Gallery that attracted the attention of the local art critics. In 1933 he went to the Mother Lode country of California, where he lived for a year and a half. On this trip he completed his WPA mural *Lumbering, Mining, and Agriculture* for Sonora High School. Soon after, he sailed on a tanker through the Panama Canal to New York, and from 1937 to 1938 traveled in Mexico and Europe. On his return to the San Francisco Bay Area, Post exhibited the watercolors he had made, receiving favorable reviews. He exhibited with the California Water Color Society in 1936, the same year in which he participated in a juried exhibition at the Art Institute of Chicago and won second prize for watercolor at the Oakland Art Gallery.

In 1940 Post began his career as a teacher, first as an instructor at Stanford University for a year and then, in 1947, as a professor of fine arts at the California College of Arts and Crafts in Oakland, where he taught until 1973. During the summers between 1945 and 1955 Post taught in Corona del Mar at the Brandt-Dike Summer School of Painting, and then at the Rex Brandt Summer School until 1977. He also instructed at San Jose State College and the San Diego Fine Arts Gallery.

Some of the awards Post received for his work are a purchase prize, the

Springfield Art Museum, Missouri (1966); first prize, Zellerbach Show, San Francisco (1975); and best of show, Society of Western Artists (1979). He also received awards from the California Water Color Society in 1942, 1947 and 1953.

Donkey Engine
ca. 1938
Watercolor on paper
16 x 15
Lent by Gordon and
Debi McClelland

From San Francisco North and the Embarcadero
Watercolor on paper
18 x 24
Lent by Gordon and Debi
McClelland

Gas Tanks—Oakland
Watercolor on paper
15 x 19
Lent by Gordon and
Debi McClelland

George Post, *Donkey Engine*, ca. 1938

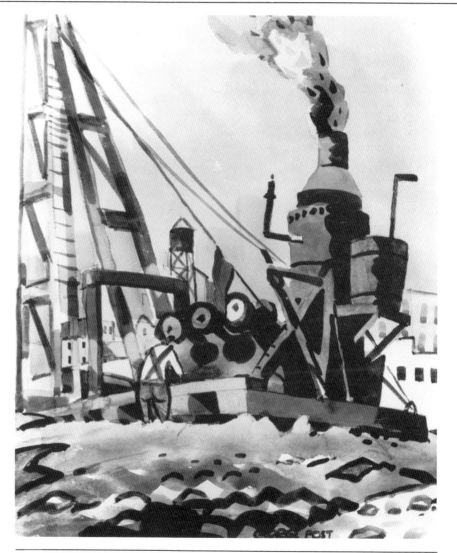

ED REEP

Born 10 May 1918
in Brooklyn, New York

Edward Arnold Reep was raised in Southern California and studied with Barse Miller at the Art Center School in Los Angeles from 1936 to 1942. He took further instruction from E. J. Bisttram, Stanley Reckless, and Willard Nash.

While still a student, Reep began to exhibit with the California Water Color Society, later serving as president in 1957. During World War II, he acted as official war artist for the Italian campaign; this won him a Guggenheim Fellowship upon his discharge in 1947.

When he returned to Los Angeles, Reep taught painting and drawing at the Art Center School until 1950. He also taught at Bisttram School of Fine Arts and Chouinard Art Institute. While teaching for only a year at Bisttram, he remained with Chouinard until 1969, moving to the new campus when it became California Institute of the Arts in 1966. He was appointed chairman of the department of painting in 1957. He became professor and artist-in-residence at East Carolina University in Greenville, North Carolina, in 1970.

Reep was commissioned by the U.S. Government to complete a mural at Fort Ord, California in 1941. He also received painting commissions from *Life* magazine and the Ford Motor Company and was a scenic artist for the motion picture industry.

He has received numerous awards for his work including the first purchase prize for watercolor, Los Angeles County Museum (1951); first prize in oil painting, Los Angeles All City Annual (1963); and a National Endowment for the Arts grant (1975). He is the author of *Content of Watercolor,* published in 1969.

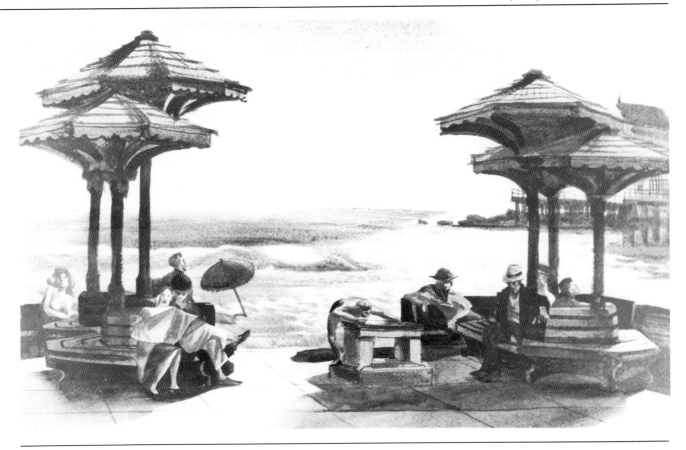

Pergolas at Venice
ca. 1945
Watercolor on paper
12 x 16
Lent by Mr. and Mrs.
Robert Crisell

ART RILEY

Born 14 September 1911
in Boston, Massachusetts

Arthur Irwin Riley studied with Barse Miller at the Art Center School in Los Angeles around 1935. He worked as an artist at MGM Studios for five years and at Walt Disney Studios from 1937 to 1965 as a background artist on animated features like *Snow White* and *Cinderella.*

Riley received an award from the California Water Color Society in an exhibition at the Los Angeles Museum of History, Science and Art in 1937. He won awards from the Laguna Beach Art Association and the Butler Institute of American Art. He has exhibited with the American Watercolor Society in New York, the Springfield Art Museum in Missouri, and the Youngstown Art Museum in Ohio. He had a one-man exhibition at the Pacific Grove Museum in Pacific Grove, California.

Riley has contributed to *American Artist* magazine and has had work published in the *Saturday Evening Post, Ford Times,* and *Life* magazine.

He is a member of the American Watercolor Society and the Academy of Motion Picture Arts and Sciences.

Yellow Cars, North Broadway
ca. 1935
Watercolor on paper
14½ x 11½
Collection of Mr. and Mrs. Philip H. Greene

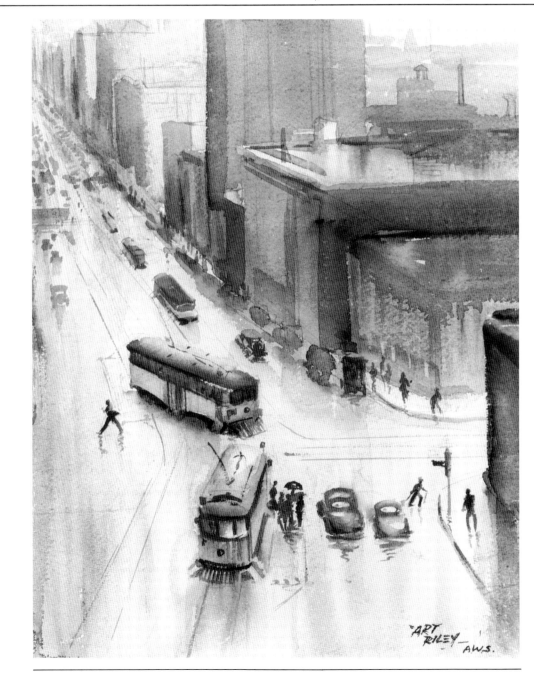

GEORGE SAMERJAN

Born 12 May 1915
in Boston, Massachusetts

George E. Samerjan lived in Boston and then in Fresno before moving to Hollywood in 1927. After his graduation from Hollywood High in 1933, he attended the Art Center School, studying with Stanley Reckless and Barse Miller. At Otis Art Institute and Chouinard Art Institute he studied with Alexander Brook and Willard Nash.

On completion of his studies in 1938, Samerjan began exhibiting with the California Water Color Society, with the San Diego Fine Arts Society, and in annuals sponsored by major institutions like the Pennsylvania Academy of Fine Arts. By 1941 he had exhibited widely, showing his work at the National Academy of Design, the Denver Art Museum, and the Los Angeles Museum of History, Science and Art.

From 1939 to 1940 Samerjan worked as a director for CBS Pacific Coast Radio Network. In 1941 he became involved in the Federal Art Project and began work on murals for the Maywood and Culver City post offices. The latter mural, entitled *Studio Lot,* featured the movie industry. He also taught at Occidental College and Otis Art Institute. In 1942 Samerjan had a one-man show at the Oakland Art Gallery and opened a studio and gallery on Sunset Strip, where he exhibited his oils, watercolors and drawings. There he finished his mural for the Calexico post office before going off to war.

The day after his return to Los Angeles in 1946, the *Los Angeles Times* offered him the position of art director. Soon after, he became creative director for *Esquire* magazine in New York. He taught painting at Pratt Institute in 1952 and graphic art and design at New York University for twenty-five years.

Samerjan received numerous awards

for his work including first prize, Art Fiesta, San Diego (1938); second prize, Laguna Beach Art Association (1939); a medal, Oakland Art Gallery (1940); a prize, California Water Color Society (1943); and a prize, the American Watercolor Society (1952).

Saturday, 1937
Watercolor on paper
14 x 22
Collection of Jason Schoen,
Houston, Texas

*Japanese Evacuation,
Terminal Island,
California,* 1941
Watercolor on paper
14 x 20
Collection of Jason Schoen,
Houston, Texas

PAUL SAMPLE

Born 14 September 1896
in Louisville, Kentucky
Died in 1974

As a child Paul Starrett Sample spent a number of years in Berkeley, Carmel, and San Francisco and later returned to live on the California coast.

His studies at Dartmouth College were interrupted by Navy duty during World War I. After graduating in 1921 and while recovering from tuberculosis, he took up painting and drawing with Jonas Lie. In 1925 he returned to California and attended the Otis Art Institute with private instruction in the studios of Stanton MacDonald-Wright and F. Tolles Chamberlin. The following year, he joined the faculty of the University of Southern California, eventually becoming chairman of the art department.

By 1930 he had a painting accepted in an annual juried exhibition sponsored by the Art Institute of Chicago. He received national recognition in 1932 when he was awarded the second Hallgarten Prize at the National Academy of Design, and first prize for painting in the Los Angeles Museum annual. His work was shown for the first time in New York at a group exhibition that same year. In 1933 he assisted David Alfaro Siqueiros on a private mural commission.

Sample received further recognition in 1934 when he had his first one-man show in New York at the Ferargil Galleries and his work traveled with the Carnegie Foundation World Tour. He spent 1936 traveling in Europe, and beginning in 1937 he exhibited with the California Water Color Society for a short time.

In 1938 Sample was appointed artist-in-residence at Dartmouth College and moved permanently to New England. From 1943 to 1944 he served as an artist-correspondent for *Life* magazine in the Pacific theater.

During the next two decades Sample participated as a juror for many annual exhibitions, including *American Painting Today,* the Metropolitan Museum of Art's exhibition of 1950.

Sample received numerous awards, including the Isadore Gold Medal, National Academy of Design (1931), and the Temple Gold Medal, Pennsylvania Academy of Fine Arts Annual (1936). He was elected a member of the National Academy of Design in 1941.

Two Men Seated, 1935
Watercolor on paper, 11¼ x 15¼
Gift of the artist, Hood Museum
of Art, Dartmouth College,
Hanover, New Hampshire

Dressing Poultry, 1936
Watercolor on paper
10¾ x 14½
Collection of Mr. and Mrs.
Philip H. Greene

Cattle Fair
Watercolor on paper, 12 x 19
Gift of the artist, Hood Museum
of Art,Dartmouth College,
Hanover, New Hampshire

In the Ring
Watercolor on paper, 11¼ x 15½
Gift of the artist, Hood Museum
of Art, Dartmouth College,
Hanover, New Hampshire

Yellow Victorian House on Hill
Watercolor on paper, 19½ x 12
Gift of the artist, Hood Museum
of Art, Dartmouth College,
Hanover, New Hampshire

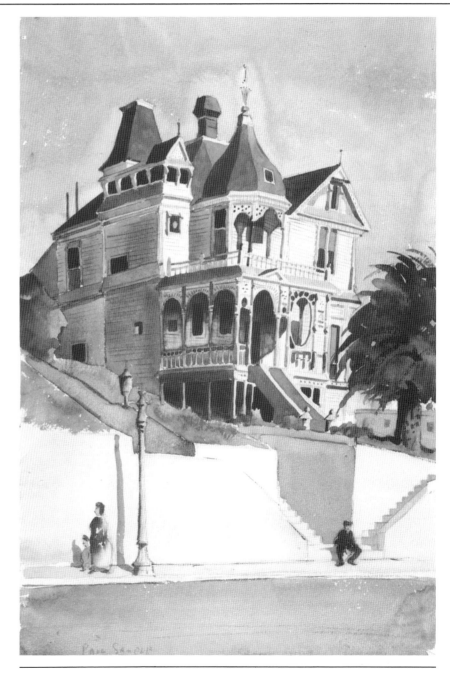

MILLARD SHEETS

Born 24 June 1907
in Pomona, California

Millard Sheets grew up on a ranch surrounded by orange groves in a rural area east of Los Angeles. After graduating from Pomona High School in 1925, he went to Chouinard Art Institute on a scholarship. He studied with Clarence Hinkle and F. Tolles Chamberlin and in 1932 assisted David Alfaro Siqueiros in the completion of a mural in the Chouinard courtyard.

After only a year and a half of study, Mrs. Chouinard asked Sheets to teach a class in watercolor painting, and so began his lifelong teaching career. Around the same time, Sheets began exhibiting with the California Water Color Society. In 1929, after completing his studies, he won the Edgar B. Davis Prize in the San Antonio Competitive Exhibition and had his first one-man exhibition at the Dalzell Hatfield Galleries. The prize money and proceeds from the exhibition enabled him to spend almost a year in Central America, South America, and Europe. In Europe, Sheets made detailed architectural drawings, studied lithographic technique, and entered a painting in the Salon d'Automne.

Sheets resumed teaching at Chouinard in 1930 and had a one-man show at the Los Angeles Museum of History, Science and Art. That year he had his first painting accepted in a national juried competition, the Carnegie International Exhibition in Pittsburgh, Pennsylvania. In 1931 he was made director of the Fine Arts Exhibition at the Los Angeles County Fair in Pomona. Until 1956 he organized art exhibitions for the fair, including national juried exhibitions of contemporary art and major exhibitions of great historical interest.

In 1932 Sheets was invited to join the faculty of Scripps College in Claremont,

California, as assistant professor of art. In 1936 he became director, building an exceptionally fine art department under the influence of his mentor, Professor Hartley Burr Alexander. In 1938 he became director of the graduate school art department.

From 1933 to 1935 Sheets served as

one of four regional directors for the Southern California Public Works of Art Program, along with Merle Armitage, Stanton MacDonald-Wright and Dalzell Hatfield. He designed seventeen Air Training Schools for the U.S. Air Force from 1939 to 1941 and went on assignment for *Life* magazine as an

artist-correspondent on the India-Burma front from 1943 to 1944.

From 1953 to 1959, Sheets was director of Otis Art Institute in Los Angeles and conducted annual painting workshops in countries throughout the world from 1965 to 1979. Between 1958 and 1961 Sheets traveled to West

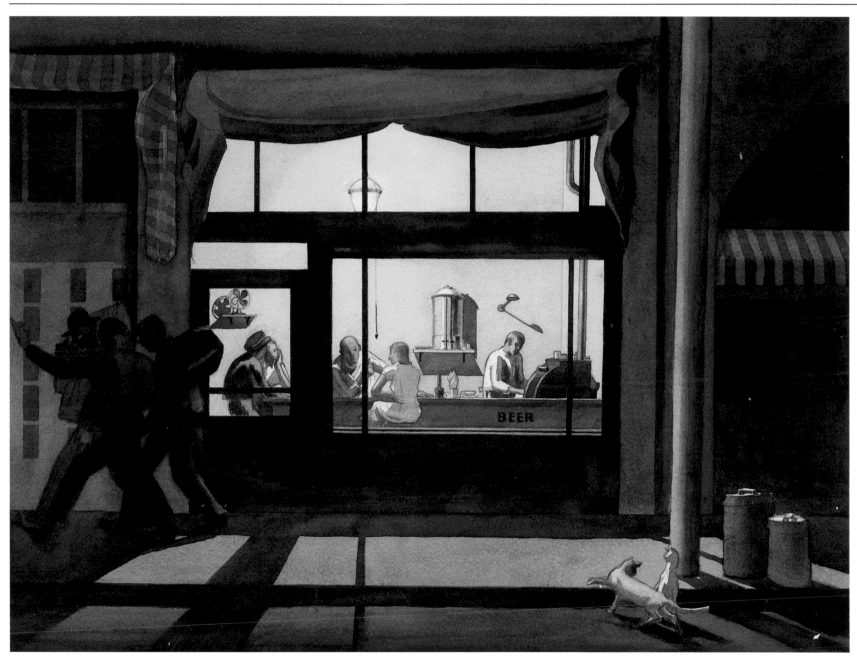

Germany as a guest of the Federal
Republic of Germany, to Japan and
Formosa on an artistic appointment for
the U.S. Air Force, and to Turkey and
Russia as an American art specialist
under the auspices of the U.S. State
Department.

Between 1954 and 1975 Sheets
designed the Ahmanson Bank and Trust
Company as well as forty Home Savings
and Loan buildings. He also created over
one hundred murals and mosaics. Sheets
has been honored by many institutions.
He was awarded an honorary M.F.A.
from Otis Art Institute in 1963 and an
honorary Doctor of Laws from Notre
Dame University in 1964. In 1977 the
National Watercolor Society honored
him on the golden anniversary of his
membership. He is a Dolphin Fellow of
the American Watercolor Society and a
member of the National Academy
of Design.

Spring Street, Los Angeles
1929
Watercolor on paper
14½ x 18⅜
Santa Barbara Museum of Art
Museum Purchase: The Dicken Fund
in Memory of Emily Rodgers Davis

Sunset Tenements, 1930
Watercolor on paper
18 x 22
Lent by Ralph and Lois Stone

Campfire, 1932
Watercolor on paper
15 x 22
Lent by Ralph and Lois Stone

Beer for Prosperity, 1933
Watercolor on paper
15¼ x 21
Lent by The E. Gene Crain
Collection, Laguna Beach, California

California Dry River Bed, 1934
Watercolor on paper
22 x 30
Lent by Ralph and Lois Stone

Paradise Cove, 1935
Watercolor on paper
21¾ x 28⅞ (framed)
Lent by The E. Gene Crain
Collection, Laguna Beach, California

Burns Brothers, 1936
Watercolor on paper
15 x 22
Lent by Ralph and Lois Stone

Backyard Quarrel, 1938
Watercolor on paper
22⅜ x 30
Lent by The Buck Collection,
Laguna Niguel, California

Miggs Ready for the Road
1938
Watercolor on paper
15½ x 22¼
Lent by Mr. and Mrs.
Millard Sheets

Pea Pickers, 1938
Watercolor on paper
14½ x 30
Lent by Mr. and Mrs.
Millard Sheets

JOSEPH WEISMAN

Born 17 February 1907
in Schenectady, New York

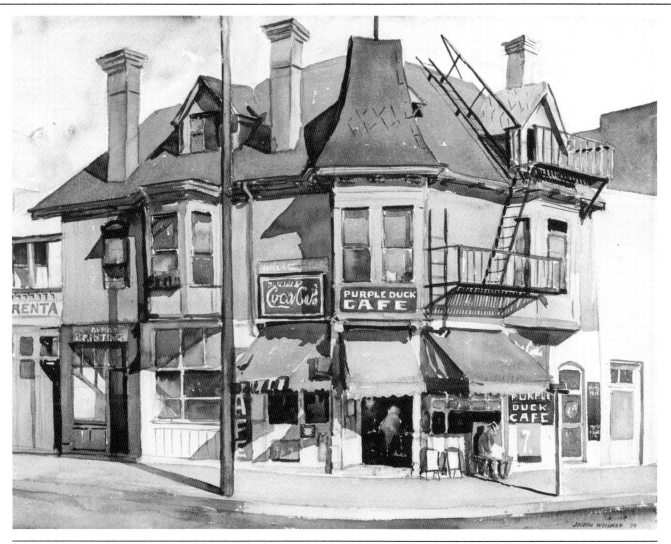

Joseph Weisman grew up in Cleveland, Ohio. Because of his mother's ill health, his family moved to Los Angeles in the 1920s. After graduating from Hollywood High, Weisman attended Chouinard Art Institute on a scholarship, where he studied with Lawrence Murphy, Clarence Hinkle, and Millard Sheets from 1925 to 1929. Later he studied at Art Center School in Los Angeles with Stanley Reckless and Barse Miller.

During World War II, Weisman was a technical illustrator for Douglas Aircraft Corporation. From 1946 to 1949 he worked in the scenic art departments of MGM Studios, Twentieth-Century Fox and Warner Bros. Studios.

Throughout this period, he exhibited with local and regional institutions and organizations such as the California Water Color Society, the San Diego Fine Arts Society, the Oakland Art Gallery, and the Los Angeles Museum of History, Science and Art. His work was also included in juried exhibitions at the Dayton Art Institute and the Pennsylvania Academy of Fine Arts.

Since the 1950s, Weisman has worked primarily as a teacher. He retired from teaching in the Los Angeles City Adult School System in the late 1960s and now teaches privately. He has completed murals on private commission for restaurants and churches in Los Angeles.

Purple Duck Cafe, 1939
Watercolor on paper
17 x 22
Lent by Joseph Weisman,
Courtesy of Arlington Gallery
Santa Barbara, California

MILFORD ZORNES

Born 25 January 1908
in Camargo, Oklahoma

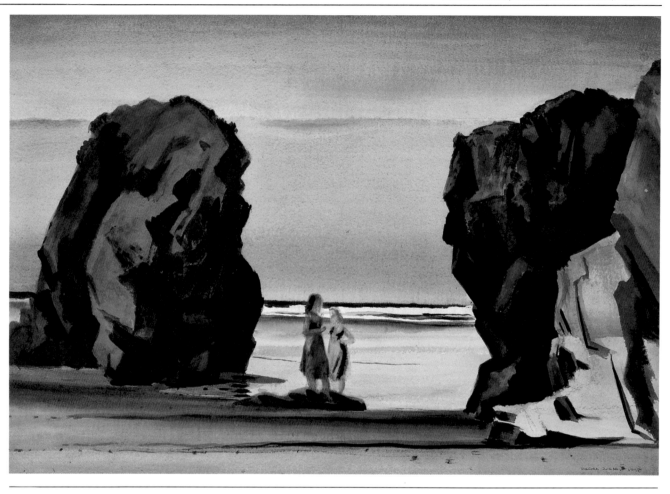

James Milford Zornes lived in Boise, Idaho, before moving to Los Angeles in 1925. After a career in the U.S. Merchant Marines, he attended Santa Maria Junior College until 1928. At the age of twenty-one he signed on with a ship's crew heading for Denmark, jumped ship in Copenhagen, and traveled around Europe. After returning to California, he enrolled in Pomona College. He had additional instruction at Otis Art Institute where F. Tolles Chamberlin and Millard Sheets were his most influential teachers.

Zornes had an auspicious start as a young artist and began receiving awards for his work in 1931. He entered the Federal Art Project as an artist in 1933, producing both murals and paintings. Approximately one hundred and sixty of his paintings remain in the U.S. Treasury Department's collection. He completed murals for the Campo, Texas, post office in 1937 and for the Claremont, California, post office in 1938. From 1938 to 1942 he taught at Otis Art Institute.

Between 1943 and 1945 Zornes served with the U.S. Army as an official artist in the Far East on the China-India-Burma front. He assisted Maynard Dixon on a mural project for the Santa Fe Railway office in Chicago before returning to California in 1946.

Zornes took a teaching position at Pomona College until 1950. Later he taught at numerous institutions including the Pasadena School of Fine Arts, the Riverside Art Center, University of California, Santa Barbara, and the Rex Brandt Summer School. He held painting workshops throughout the West and taught summer classes in Mount Carmel, Utah.

In addition to his work as a painter, Zornes has been a freelance writer, cartoonist, and surveyor for the General Land Office in Yellowstone National Park. He is the author of *Journey to Nicaragua,* published in 1977.

Zornes became active in the California Water Color Society in 1934, serving as president in 1941. His work was included in the 1937 traveling exhibition, "The California Group." He has received numerous awards including first prize, Chicago International Watercolor Exhibition, Chicago Art Institute (1940), and the American Artist Magazine Medal of Honor, American Watercolor Society 96th Annual Exhibition (1963).

Adobe Chapel, 1933
Watercolor on paper
15 x 22
Lent by Jay T. Last

Untitled, 1934
Watercolor on paper
12 x 15
Lent by Gordon and Debi McClelland

The Shore at Casmalia
1938
Watercolor on paper
14½ x 21½
Lent by Scripps College, Claremont, California